The Craftsman's Art Series

The Craft of
Photography

Roy Hayward ARPS

Stanley Paul, London

Introduction

This book is for people who wish to get more out of photography than the simple pleasure of taking a snapshot. The author assumes almost no previous knowledge on the part of his readers, and progresses step by simple step through the important business of buying a first 'real' camera, choosing a suitable film and working out correct exposure. Much of the fun and also the art in photography comes from developing and printing one's own film and this book gives straightforward instructions on how to do this.

Following the guidance given, readers will be able to achieve good results without spending a fortune or entering the realms of chemical fantasy; in due course, readers should arrive at the point where they have thoroughly understood tha basics and are well equipped to experiment and branch off into more specialist areas of photography.

Stanley Paul & Co Ltd, 3 Fitzroy Square, London W1

An imprint of the Hutchinson Publishing Group

London Melbourne Sydney Auckland Wellington Johannesburg
and agencies throughout the world

First published 1976 © Roy Hayward 1976
Illustrations © Stanley Paul & Co Ltd 1976

Printed in Great Britain by litho by The Anchor Press Ltd
and bound by Wm Brendon & Son Ltd, both of Tiptree, Essex

ISBN 0 09 124690 3 (hardback) 0 09 124691 1 (paperback)

Contents

1. Taking a Snapshot

In the Western world there are probably about as many cameras in use as there are families to use them. The number of photographs these cameras produce between them each year must be enormous. Holiday snapshots, mostly, as well as weddings, christenings, parties – all the family events that need to be permanently recorded and then brought out from time to time as happy reminders of happy times.

These are personal pictures that have very little meaning or interest to anyone outside the intimate family group. They are not the stuff of advertising, the newspapers, public exhibitions or competitions where the public is critical and, more often than not, amazed at the way the camera may be exploited in expert and professional hands.

Snapshots are memories that can be brought out again and again for inspection and review, but of all the millions of snapshots taken every year, the percentage of disappointments must also be enormous. So often are the cries of 'What a pity, it hasn't come out!' or 'You must have moved!' or 'Just look at that expression!' as if photography itself was still a new invention full of uncertainty and surprise. The real surprise is that in a modern world where we take sophisticated technology in our homes for granted we still find excuses for bad pictures taken on automatic, instant cameras designed by their makers to be as nearly foolproof as it is possible to achieve. So how can we improve our own percentage of successful pictures in each expensive roll of film?

The very first step in better picture-making must be to understand how to use the camera. Even if the instructions that came with it have long since been mislaid, it is worth asking at almost any camera shop for another copy to study or, at least, for a rebriefing on how to use it properly. If it is a simple camera, there is very little to learn; certainly less than knowing how to cook a batch of currant buns.

A good start to more successful picture taking is to set the controls on the camera in the morning, before going on the beach; before catching the coach; before the excitement begins. Most simple

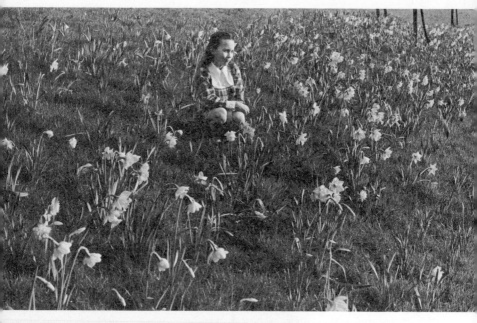

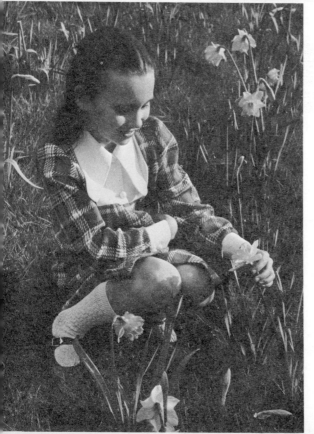

A snapshot of a girl amongst daffodils. But what is really the important part of the picture? The daffodils or the girl? *(Ivor Hibberd)*

Same girl – same daffodils. By getting closer to the girl she now fills the frame and makes a more natural picture. *(Ivor Hibberd)*

cameras have settings for bright sunshine, cloudy but bright, over-cast, dull: a faraway picture, a medium close and a really close picture. Set these for what you think might be right when the time comes.

If it is a wedding, for example, set the camera in the morning before the rush begins. Set it according to the weather and choose a middle-distance shot. Not only will it be ready to cover most of the pictures required anyway, but it is also set ready to snap at the unexpected event that might crop up on the way to the church with more than a fair chance of a reasonable picture as a result. But under normal circumstances always check the camera settings again before taking a picture or a series of pictures at the same spot. It is a moment's work and a habit that is worth while right from the beginning.

Hurry is rarely necessary. The professional can sometimes take hours before he is satisfied with the picture in his viewfinder. It is worth taking a few moments for a snapshot too. So few people take enough time to look at everything in the viewfinder and decide if it is all needed. Attention is often drawn too much to the main subject to notice what else is going on within the frame of the picture. It takes only a moment or two to look properly at what is there; study the whole scene as if it was a painting in the art gallery; scan from side to side, top to bottom, look for distractions and intrusions. This is the beginning of successful picture-making.

Doing this properly will lead to questions about composition. Is the subject too small? Is there too much confusing background? Take a pretty girl in a yellow-flower print dress standing some distance away in the middle of a field of yellow daffodils. Which is really more important – the field of flowers or the girl? What is so difficult about approaching closer, altering the distance-setting and having another look through the viewfinder? Now it is clearly the girl amongst fewer daffodils with the emphasis on the girl – and she will be better pleased for sure.

Many pictures are spoiled by cramming too much into the picture. 'There's Dad beside the coach that has stopped in the town square in front of the fountain with the cathedral in the background and you can see the mountains over the house-tops, etc., etc.' Maybe such a picture might have special appeal within the family circle and, done well, is full of useful, interesting information recalling the details of a pleasant experience. Frequently a more lasting reminder and a more pleasing picture can result by splitting up the details and taking two or more pictures instead. Perhaps a general view at a distance first and then a close-up beside the foun-

If the background is too confusing, go in close and try to fill the viewfinder with the subject. *(Roy Hayward)*

tain or of Dad entering the cathedral door, picking out the main features of the place carefully.

But watch those poses! It is the self-conscious, uncomfortable element of the sitter that so often jars and spoils the effect. Adults, unlike children, do not like posing for pictures. It is usually easier if grown-ups and even children do not have to look at the camera lens. Ask them to look at something else – even someone else – just outside the picture area. This will give a much more relaxed and natural effect which might even persuade the sitters to be photographed again when they see the results.

Look through the viewfinder at the picture contained within the frame. Different, and often better, pictures can be discovered by moving round the subject one way, then the other. Pictures need not always be taken with the camera at eye-level, five feet or so from the ground. Look at the subject through the viewfinder from near the

Get the person to look at something outside the picture area. Never ask *anyone* to 'Watch the Birdie'. *(Roy Hayward)*

ground level. Stand on a wall or on something safe and stable that will give a higher point of view, and look down on the subject. Young children and pets often look better and more natural taken from their own level. Shots looking down from a high vantage point on street scenes, beaches and some landscapes can be dramatically different. The group being photographed may be laughing, talking or making jokes and wisecracks about the photographer to hide their own discomfort. Do not be distracted from finding the best possible viewpoint. Think of what has to be done and how the picture will be enjoyed when it is shown a long time after the ribald remarks have been forgotten. When the moment comes to press the shutter, hold your breath *and* your tongue. With the shutter speed of something like 1/60th of a second, this should be possible for almost anyone and it also helps to eliminate 'camera shake'. The camera should normally be kept rock steady at the time the shutter is released. Adopt a well-balanced stance, steadied by leaning on a wall, against a tree, over the back of a chair – there are many ways of ensuring camera is firm and that the picture will be sharp. Then the cry of 'You must have moved!' will not be brought out as a covering excuse for bad photographic technique.

2. The Camera

For many people the snapshot is the beginning and the end of photography, but real photography starts when the experience gained from taking holiday pictures of the family leads towards pictures that are less personal and more appropriate for viewing outside the immediate domestic circle. Take out the personal element of any snapshot and what is left is the start of real picture-making.

In fact, many holiday snapshots are taken with no personal element in them. They are almost, but not quite, pictures of photographic merit: the mountain views, the boats at anchor. If these pictorial snapshots lead on to an interest in real photography, then the enjoyment of an absorbing hobby begins.

Very soon, the old family snapshot camera will be found to have certain limitations. The question will arise, what sort of camera should one move on to? There are many sorts of photography that can be explored indoors and out of doors, for the highly energetic and active or the less energetic – not forgetting the elderly and the physically handicapped. Portraiture, natural history, sport of all kinds, land and seascapes, photographing collector's items such as glassware and antiques; there are many subjects where photography can be used not only in a specialized way but to extend an already established interest.

Any camera, whether it be simple or highly complicated, can be reduced to common basic essentials: a light-tight box with a small opening, containing a lens that directs the light from outside, to a film inside which is on the opposite side of the box to the opening. The opening is normally kept closed by a light-tight *shutter* and this shutter can be opened and closed for whatever time is needed for light to enter the box and expose the film correctly. Some shutters can be set to open and close at different speeds, from thousandths of a second to a duration of several seconds.

The size of the opening – the *aperture* – can be altered by means of an iris, which is often called a diaphragm, that decides how much light will be allowed in to the camera to expose the film while the shutter is open. These basic essentials, lens, shutter aperture, film

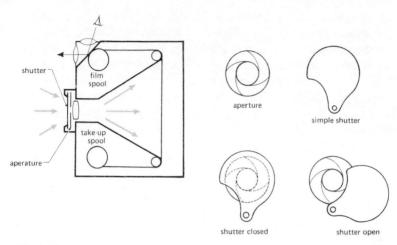

The basic camera

and light-tight box, have been put together in a variety of shapes and sizes by designers and manufacturers to meet every possible photographic requirement.

Buying second-hand

There is, of course, some risk in buying second-hand, but reputable dealers in second-hand cameras and accessories tend not to buy unsalable equipment. Anything accepted in part exchange is, more often than not, the pride and joy of a keen enthusiast who is up-grading his own equipment in an effort to improve his photographic standard.

Second-hand equipment is generally checked by the dealer's technicians and, where necessary, repaired before it is put into the window for sale. It is sold, often against some sort of guarantee, and although the camera has been given an unknown amount of work by its previous owner it probably has plenty of useful life left.

Examine a second-hand camera carefully for obvious damage. Dents and scratches may affect its performance. The tiny screws holding parts together should be looked at for signs of burrowing into the inside which might have done untold and unseen damage. The shutter mechanism should feel and sound smooth and a careful study of the shutter itself should show if there is any uneven wear or damage. If possible, a second-hand camera should be tried out with a roll of film, exposing each picture with different speeds and

aperture settings. Many reputable dealers, who are often photo-graphic enthusiasts themselves, will agree for this to be done.

For cameras that accept interchangeable lenses, the lens should be firmly locked into position on the camera with no loose movement. The focusing ring should be smooth with no slack play and it should not sound 'gritty' as it is focused. A camera and lens may be well worn and look less pristine than a new model, but good wear may indicate long and loyal service in the hands of a previous owner who cared for it well.

It is often wise to avoid cameras with rare and unfamiliar trade names unless a good report can be had from an adviser you respect. Studying dealers' advertisements in camera magazines gives the best idea of a fair, average price with an idea too of what models are the most popular on the market.

Types of camera

The smallest of the pocket cameras uses 16 mm or 110 cartridge film and produces very small pictures (13 × 17 mm). A whole range of accessories designed to be used with these cameras is available; flash equipment, tripods, processing equipment, enlargers, pro-jectors, etc. The picture size is such that they have to be enlarged to be viewed which may mean a deterioration in quality. However, the quality of these small pictures can be very high and may be compared with some larger film sizes. Many of these subminiature models can be operated without needing great technical knowledge or skill.

Another range of simple 'point and shoot' cameras, that are a little larger than the subminiature, uses the 126 cartridge-loaded film. These instant, automatic cameras produce pictures 28 × 28 mm which are of good size for enlarging and projecting. This is a model used mainly for snapshots. They are cheap, easy to load and use but have only limited photographic possibilities. Negative and slide quality is perfectly adequate.

The most widely used all-purpose camera favoured by amateur and professional is in the 35 mm range. There are two distinct types, the non-reflex or viewfinder camera and the single-lens reflex (S.L.R.) camera.

The non-reflex type can be a simple, uncomplicated camera that only requires focusing and aperture adjustment before the picture is taken. At the other extreme these cameras can be found with every sophisticated device to ensure perfect results with fully automatic electronic exposure control and accurate focusing by rangefinder

Instant cameras

Single lens reflex (S.L.R.)

Polaroid

Rangefinder 35 mm. cameras

Twin lens reflex (T.L.R.)

Hassleblad, Bronica type

Sub-miniature

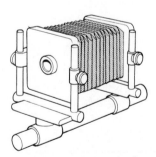

Studio camera (swingback, tilt front)

Types of camera

(where the central part of the picture, seen in the viewfinder, is split into two parts and the two parts are brought together as the lens is focused). Some viewfinders have built-in warning symbols to indicate when the light is too low for a successful picture to be taken. Many of these cameras have only one fixed lens but some are made to accept a number of different lenses of different power for close-up work and far-away subjects. The greater the versatility and the more complicated the design, the more expensive the camera.

The single-lens reflex (S.L.R.) like the non-reflex camera has been designed to use 35 mm film which produces high-quality 24×36 mm pictures. The name 'single-lens reflex' means that the picture as seen in the viewfinder is exactly as it will be recorded on the film and the alteration of focus and aperture and the composition of the picture can all be observed before the exposure is made.

It is a great advantage to be able to see the picture as the film will record it and this factor alone gives the single-lens reflex great popularity. A whole range of accessories is available for most models and many of these are interchangeable between cameras of different makes.

Accessories and attachments and various lenses are specially designed to increase the flexibility of the camera's operation and enable the photographer to tackle a wide variety of photographic tasks: photographing through microscopes, very close 'close-up' work, remote control, very long-distance subjects, photo-copying, and the opportunity to take pictures in a variety of lighting conditions. Some incorporate electronically controlled shutter speeds and aperture settings, others have electrically driven motors for taking a number of pictures faster than can be operated by hand. Most amateur photographers will not need these technological refinements, especially as the cost of cameras generally increases with complexity. To this must be added the cost of accessories and attachments themselves, some of which may be many times greater than the cost of the camera.

The twin-lens reflex (T.L.R.) is a larger camera looking like an upright oblong box with two lenses, one above the other. On the top is a glass viewing screen showing the picture. The top lens of the two is used only for passing the picture being viewed on to the viewing screen and has no shutter or aperture control. The lower lens is the taking lens. Both are in exactly the same plane. As the picture is focused on the screen, both lenses are moved forward or backward together. Once the picture is properly focused on the screen it will also be properly focused on the film.

One slight drawback may be that the picture on the screen appears

upside down, but there are some photographers who prefer it this way and are able to concentrate upon the overall composition more closely. These cameras have a number of lenses available for different kinds of pictures. The twin lenses are mounted on the same base plate, the taking lens and the appropriate viewing lens complete. Buying two lenses at once adds to the cost of these fairly expensive cameras, but the superior quality of the larger-format pictures ($2\frac{1}{4} \times 2\frac{1}{4}$ in.) means that many professional photographers prefer them.

Some single-lens reflex cameras also use larger-size film for a better-quality result. These cameras are exactly the same in their operation and design as their smaller 35 mm counterparts and as the size increases and the design is improved for better results, the cost of the camera and the cost of using it increases and moves into the professional areas of photography.

Here cameras use larger-gauge films and film plates to produce pictures of 5×4 in. and even 10×8 in. They are too heavy to be held by hand and are supported by substantial tripods and stands designed to be rock steady under almost any conditions. Most studio or view cameras may rudely be compared with old-fashioned portrait cameras, where the photographer studied his upside-down picture under a black cloth, but, of course, the modern equivalent is much more sophisticated. The lens, mounted on a lens board, can be tilted from side to side or up and down and the back of the camera containing the film or film plate can also be angled. A combination of both these movements can correct perspective and vertical distortions as may be found when taking architectural subjects.

Cameras have been used for more than a hundred years and all are basically the same in principle. Only one substantially different kind of camera has been designed in recent years and that is the Polaroid, which develops and prints the picture as soon as it is taken. It is still a basic camera, but the film material has its own chemicals for processing the final print in black-and-white or colour. There are many models produced that give instant pictures of different sizes. Apart from the popularity it has for the average photographer, these cameras are used extensively by professionals and scientists. It is useful, for instance, to a commercial photographer, who has set up an expensive advertising picture in a studio, to check the result on a polaroid print first before committing himself to the costly business of taking the picture and waiting for it to be processed. Passport photographs and portraits can be produced while the customer waits. Instant comparison between one picture and another

taken a few minutes later is a useful diagnostic tool in hospitals. The quality of the pictures is good and the size of the pictures varies according to the size of the camera. One disadvantage is that most polaroid cameras do not produce negatives: they only provide one-off prints. Duplicates can be made but these are expensive and often unsatisfactory.

Colour in polaroid cameras is more expensive than black-and-white, but the cost has to be considered in relation to the convenience of having an immediate result that can be checked and the picture taken again if it is not quite as it should be.

Some useful accessories

There are very few additional extras provided on the market for the simple snapshot cameras. For the more expensive cameras and particularly the S.L.R. cameras there are very many indeed. Some accessories are useful for general photographic work, but there are many designed for specific tasks that would only be used now and again. In cutting costs, the urge to buy an expensive additional extra would have to be considered against the amount of use it may get.

One useful attachment is a *lens hood* which can be attached to the front of the lens to prevent the sun, or reflections of the sun, from striking the lens. The lens hood must be the correct size and shape. If it is too small, the rim will be included in the final picture.

A *tripod* is often essential for pictures where low light values require slow shutter speeds, or any occasion where it is necessary to hold the camera perfectly still during exposure. A substantial, well-constructed tripod is far better than one with elegant spindly legs. The heavier type is sometimes a nuisance to carry around, but the pictures will show the difference, which is what really matters. It is seldom possible for a camera to be hand-held sufficiently still for shutter speeds under 1/60th second and it is camera shake that blurs and spoils many otherwise good pictures.

With the tripod, a *cable release* is also a necessity. The cable is attached to the shutter-release button. The smooth operation of the cable-release plunger sets the shutter off without juddering the camera – there is little point in having a tripod to keep the camera steady if the shutter is to be given a heavy thumb jab to set it off.

Filters for black-and-white photography can produce dramatic effects in otherwise ordinary pictures. A *lens brush* of the blower type and a *lens cloth* are essential in keeping the camera and its equipment free from grit, sand and dust. Every time the camera

A strong, sturdy tripod will hold the camera steady when using slow shutter speeds. *(Ivor Hibberd)*

Bellows unit attached between normal lens and S.L.R. camera. *(Ivor Hibberd)*

Using a cable release to prevent camera shake when shutter is released. A cable release is particularly useful when taking close-ups with bellows and extension tubes and when shutter speeds are less than $\frac{1}{60}$th sec. *(Ivor Hibberd)*

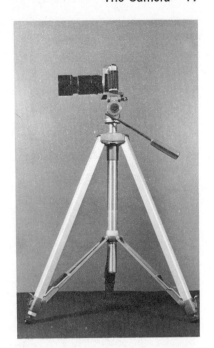

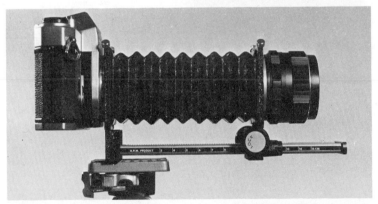

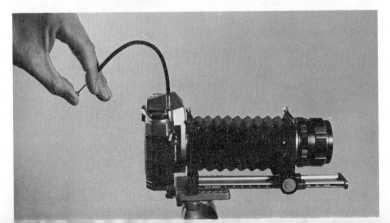

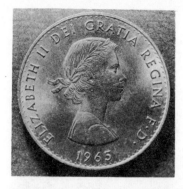

Use of bellows (a) Elizabeth crown piece using minimum amount of bellows extension. *(Ivor Hibberd)*

Use of bellows (b) close up of part of same coin using maximum bellows extension. *(Ivor Hibberd)*

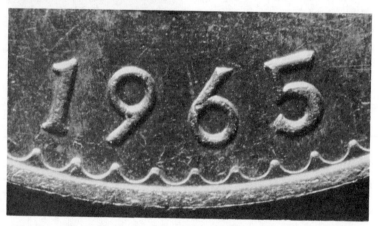

body is opened to load a new film it is always worthwhile giving it a light dusting and blowing. The lens, though, should be treated with greater respect and occasional gentle cleaning with a dry lens-cloth should be sufficient to keep it clean. Never polish a lens as one might clean a pair of spectacles and never actually touch the lens with the fingers. The very thin coating or 'bloom' on the lens that makes it appear brownish or purple in the light can be affected by natural oil in the fingertips and rubbing with a cloth to get rid of a smear, unless very gently done, can ruin the surface.

The best way to begin serious photography is to start with a camera that seems to meet most of your current needs but one that can also take accessories later. When the camera's capabilities have been mastered, then is the time to add a new lens, a set of filters, flash equipment, extension tubes and so on. To have all the gear at once is not only confusing and unnecessary, but trying this, then that, attachment produces a prodigious number of wasted pictures, which is a very extravagant way of pursuing the hobby.

3. The Film

Think of the magazines and newspapers – the dailies, the weeklies, and the quarterlies – on all the bookstalls of the countries of the world. Think of the books – upright, side by side marching along the miles of bookshelves in shops, offices, libraries – and it must become obvious that photography plays a major role as a partner to the printed word. Surprisingly, the pictures are, mostly, black-and-white. Surprisingly, because we live in a world of colour. With modern photography, which reproduces colour accurately and reasonably simply, it might be reasonable to suppose that black-and-white had had its day and been overtaken by colour completely. That it has not done so is partly tradition, partly the higher cost of colour printing and partly speed of operation. A black-and-white picture can be taken in the afternoon, processed in a few moments and be on the front page of the evening paper only hours later. Colour processing takes longer and is a measurably more expensive business and it is questionable whether good black-and-white pictures will ever be superseded by colour.

Buying a film

Choosing a film can be a confusing business for a novice. Films can come in 'cartridges', 'cassesttes' or rolls. They may be marked with figures like '120', as well as figures indicating 'speeds'. They also come in sizes, denoted by different film widths, for instance 16 mm or 35 mm. Some are designed to make negatives for printing, some to make transparencies for viewing on a screen. Some are monochrome, some colour. Of the colour films, one type may be suitable for daylight pictures only. In some cases the type of camera you have will dictate your choice, in others, as with film speed, you can choose the film most suited to the type of picture you want to take.

Film speed

All packets of film indicate 'film speed', that is, the sensitivity of that

film to light. This is indicated by the letters ASA followed by a number and a different number followed by the letters DIN. For instance, Kodak High Speed Ektachrome film is marked ASA 160. 23 DIN; Agfachrome ASA 50. 18 DIN; Kodachrome 11 ASA 25. 15 DIN; Ilford Pan F. (Black-and-white) ASA 400. 27 DIN.

ASA are the initials representing the American Standards Association and DIN represents the Deutsche Industrie Norm – the German standardization organization. The American set of standards laid down for films are the same as the British Standards.

The figures are arrived at mathematically and indicate the approved standards laid down for the sensitivity of the film's emulsion: the higher the number, the more sensitive is the film to light and the lower the number, the less sensitive it is to light. The ASA figures are arithmetic. If the film speed is doubled, the ASA number is also doubled. The DIN figures are logarithmic. An increase of three means the film speed is doubled. A high-speed film (with a high number) is said to be a 'fast' film and a low-speed film (low number) is said to be a 'slow' film. A fast film is suitable for poor lighting conditions such as badly lit interiors or bad weather. A slow film would be suitable in situations where the lighting is plentiful, such as a photographic studio and well-lit, sunny exteriors. In general, fast films give a less sharp, more grainy result than slow films: you lose on quality what you gain in speed.

The rating system laid down for films manufactured in the Soviet Union is the GOST, which is used extensively in Eastern European countries, and although their numbers are not the same as ASA or DIN numbers, the principle remains the same; the higher the number, the more sensitive (or fast) is the film.

When buying colour films you may get them mixed up in your mind. As a general rule, colour negative film for prints and colour reversal film for slides may be identified by the suffix to the trade name. Colour negative film has the suffix 'color' e.g. Kodacolor, Ektacolor, Agfacolor, etc. Colour-reversal film for slides has the suffix 'chrome', e.g. Kodachrome, Ektachrome, Agfachrome.

Film sizes

There are many different sizes of film to suit different cameras. Some are used by professionals for studio work, enabling negatives and transparencies of 10×8 in. to be made, while, at the other end of the scale microfilming can accommodate a page of a newspaper in a picture the size of a matchstick head. The most popular film

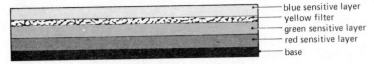

blue sensitive layer
yellow filter
green sensitive layer
red sensitive layer
base

Construction of colour reversal film

sizes for most people's everyday use are the 120 (one-twenty); the 220 (two-twenty); 35 mm (thirty-five millimetre); 126 cartridge (one-two-six) and the 110 cartridge (one-ten).

The 120 film is used in the larger, twin-lens reflex cameras favoured by many professionals for its picture size. It is also used in some of the older-type folding cameras that can sometimes be found second-hand. The picture areas on the 120 vary slightly, according to the type of camera used; either eight exposures of $2\frac{1}{4} \times 3\frac{1}{4}$ in. ten exposures of $2\frac{1}{4} \times 2\frac{3}{4}$ in. or twelve exposures of $2\frac{1}{4} \times 2\frac{1}{4}$ in. The film has a backing paper with printed exposure numbers that can be seen through a window in the body of the camera when winding the film on.

The 220 film is the same as the 120 in picture sizes, but, by using thinner backing paper or in some cases no backing paper at all, more film can be accommodated on the spool and generally twice as many exposures obtained compared with the 120.

The 35 mm is the film size most widely used by amateurs and professionals. It is commonly contained in a daylight-loading cassette in two lengths, either thirty-six or twenty exposures. The size of the picture in most cameras is 24×36 mm (roughly $1 \times 1\frac{1}{2}$ in.) After a 35 mm film has been exposed in the camera it must then be rewound back into its light-proof cassette by means of a release button and a winding handle incorporated in the body of the camera. It is possible to buy 35 mm films of various film speeds, black-and-white and colour, by mail order in rolls of various lengths up to thirty metres that may be used for reloading cassettes at home. This saves considerably on costs.

The 126 cartridge is a film contained entirely within a plastic, light-tight container that is dropped into the camera and wound on, shot by shot, automatically until the film is completely exposed. It is then taken out of the camera without having to be rewound. It is specially designed for the simple automatic-loading, 'point-and-shoot'-type camera. There are two versions of the film giving either twelve or twenty 28×28 mm exposures. For developing 126 cartridge film at home it is useful to know that the film width is the same as 35 mm and the cartridge containing the film, which is not reloadable, has to be broken in half to get at the film.

The 110 cartridge is on much the same principle as the 126, but is a smaller film width (16 mm) producing much smaller pictures (13 × 17 mm) roughly a quarter of the size of 35 mm. In spite of the very small picture size, the quality of the 110 film is such that enlarged prints and projected slides from this film compare very favourably with the quality of the 35 mm. The 110 cartridge is specially designed for the subminiature, compact 'point-and-shoot' camera.

What is a film made of?

The black-and-white (monochrome) film

Once the camera shutter has been released and the picture exposed on to the film inside the camera, several processes have to be followed before the picture finally becomes a permanent print on a piece of paper or a slide that may be projected onto a screen. To know a little about the film itself, what it is made of and what happens to the picture on the film after it has been exposed, adds interest and understanding when it comes to home processing later.

Black-and-white film is made up of two parts, the base and the emulsion. *The base* is the transparent part of the film that used to be made of celluloid. Some of the very early movie films used celluloid-based film which was highly inflammable, but all film on the general market these days is made of plastic or cellulose acetate material which is perfectly safe.

The emulsion is the important part of the film. It is a special chemical mixture of microscopic silver bromide grains held in position by gelatine. This mixture is coated about 1/1000 of an inch thick, along the length of one side of the film base. Although the gelatine of the emulsion is fairly solid, it is pliable enough for the film to be rolled on a spool but it is also soft enough for it to be damaged and easily scratched if handled carelessly.

Silver itself has the characteristic of being sensitive to light, as anyone who has had to polish silver ornaments around the home will know. This is also true of the silver bromide grains contained in the emulsion. They change their characteristic in proportion to the amount of light that reaches them; the greater the amount of light the greater the change, the less light, the smaller the change.

When a picture is taken, the camera's lens focuses the picture clearly on to the film. In the picture some parts will be brighter and some darker than others. As the pattern of light and shade that make up the total picture falls upon the film, some silver grains

receive a great deal of light, some not so much and possibly – in the darkest, blackest shadows – no light penetrates to the film's emulsion at all. All the grains that have been changed in the picture area on the film now represent a latent image – a potential picture – of what was seen in the viewfinder and allowed to reach the emulsion of the film. That latent image has to be protected from any more light falling on it, until it is 'developed' and 'fixed' by a simple chemical process.

In the developing process, the chemical developer softens the gelatine sufficiently to get to work on the silver bromide. Those grains that had a great deal of light are altered from silver bromide to black metallic silver. Those that had less exposure produce less metallic silver. The grains that had no exposure remain as they were, unchanged until the second process – the fixing takes place. At this stage these unaffected grains are simply dissolved away altogether, leaving a clear area on the film.

Most fixing solutions contain a hardener that restores the gelatine to its firm state again after the film is finally washed and dried. After developing and fixing, the film can be examined in normal lighting and it is clear why it is now called a negative. The light and shade of the original picture is in reverse, the blacks are white (clear film), the whites are black (metallic silver) with varying shades of grey in between. From this negative the final picture is printed on specially prepared light-sensitive paper which reverses the blacks and whites again, back to the original picture.

Colour-reversal film

This is the film that is probably the most familiar to camera owners. It is the transparency or slide that gets projected on to a screen or examined through a hand viewer. The colour-reversal film is not so very different from the black-and-white film. It has the same transparent, plastic base and it has an emulsion on one side of the base. Again, it is the emulsion that is the important part. In the case of colour, the emulsion is like a three-decker sandwich. Next to the base, is a layer of silver grains similar to those in the black-and-white film but made in such a way as to be sensitive to red light. The middle of the sandwich is sensitive to green light and the top layer is sensitive to blue light. Between the top (blue) layer and the middle (green) layer is a thin yellow layer that acts as a filter to prevent blue light from entering the layers below.

The three light-sensitive layers of primary colours are able to

record, in their own shades and hues, all the colours of most subjects being photographed.

As the picture in the viewfinder is exposed through the camera's lens on to the film, it first arrives at the layer sensitive to blue. This layer records the blue parts of the picture. The light from the picture then passes on to the green-sensitive layer. Here the green tones of the scene are recorded. The light continues through to the red sensitive layer that records only the red parts of the picture.

During the development process the action is again similar to the black-and-white film, where the exposed silver bromide grains are converted to black metallic silver in proportion to the amount of light each grain received during exposure. When the unexposed grains have been dissolved out, the film looks exactly like a black-and-white negative with no colour at all.

Then comes the surprise part of the process. The whole film is given a few seconds total exposure to a powerful white light and it takes a moment's courage for anyone who has developed a black-and-white film to take a colour-reversal film out of the dark, and give it a good saturation of brilliant white light. But, far from ruining the film, this is what does the trick in reversing the negative into a positive.

After this apparently brutal treatment, the process is continued. More chemicals introduce colour dyes that replace the exposed silver grains, leaving the image of the original picture in its true, original colours.

4. Exposure

It is worth remembering that those superbly produced pictures in exhibitions, magazines and books have been made on exactly the same kind of film used by amateur and professional alike. No matter who uses the film, it is capable of giving a perfect result but only if it is given the correct amount of light. A correctly exposed picture, properly focused has a very special appeal. It is crisp, fresh, not too dark from under exposure, not too wishy-washy from over exposure. Achieving this exact exposure is the craft that every photographer is aiming for. Fortunately, most films are not absolutely critical; they do allow a little tolerance. A fraction too much or too little exposure will be generally acceptable, but the aim is to get as close as possible to the exact exposure the film was designed to have.

Most cameras, with the exception of the simplest 'point-and-shoot' automatic models, have two controls, the shutter and the diaphragm, which enable the photographer to achieve this desirable state.

Controlling the exposure is to control the intensity of the light reaching the film. The shutter controls the length of time the camera will remain open to let the light through. The diaphragm or iris controls the size of the opening through which the light passes during the time the shutter is open.

If the opening is made very small indeed, then a very small amount of light will get in, but if the shutter is opened and allowed to remain open for some time, then more light will pass into the camera. In the same way, if the opening is made very large the same amount of light may be permitted to enter the camera by setting the shutter to remain open for only a fraction of the time.

There is, however, a small problem for the photographer and his film. By adjusting the shutter speed and the aperture the intensity of light can be controlled for most general purposes. However, where the light is so poor that the aperture is wide open and the shutter set to remain open a fairly long and apparently correct time the picture will still be under-exposed. At the other extreme, where the light is so bright that the aperture is set to its smallest size and the shutter set to be open for a very brief period then the film will not

be exposed properly either. A slightly longer exposure is needed in both cases. These are situations at the limits of the film's capability, but the conditions can sometimes occur both when taking indoor pictures without sufficient light and in very bright, sunlit beach and snow scenes when the sunshine is brilliant and the glare strong.

The Shutter

To indicate the different 'shutter speeds' (the time the shutter is to remain open) there is a standard and universally used scale to be found on the lens or the camera body. A typical scale of markings would be in the range: 1000, 500, 250, 125, 60, 30, 15, 8, 4, 2, 1, B, T. These figures from 1000 down to the number 2 are fractions of a second: 1/1000th of a second, 1/30th of a second, 1/8th of a second, $\frac{1}{2}$ of a second and so on. The 'B' used to be called 'bulb' in the early days of photography when long exposures were more common than today. If this is selected, the shutter remains open for as long as the shutter button is held down and closes again when the finger pressure is released. The 'T' is for longer exposures than 'B'. 'T' is for time exposure when it would be more convenient to open the shutter, leave it open for maybe several seconds and then close the shutter again. Press the shutter release once, the shutter opens; press again, it closes.

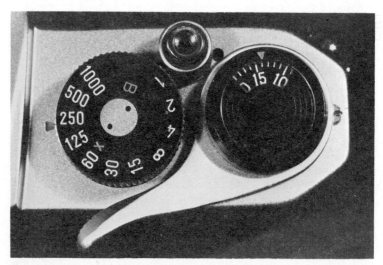

Shutter speeds on a typical single lens reflex camera. This one has 'B' but no 'T' setting. The 'X' is the shutter speed setting for flash.
(Ivor Hibberd)

Working from half a second upwards, each setting is just about twice the speed of the previous setting: 1/30th is roughly twice as fast as 1/16th and 1/60th is twice as fast as 1/30th. The higher the number on the scale, the faster is the action of the shutter which reduces accordingly the amount of light that can get into the camera.

Why do cameras have such a variety of shutter speeds, from very fast indeed to the facility to hold the shutter open for as long a time as one chooses?

If the subject being photographed is in movement, for instance an athlete running, a car moving quickly, a river flowing over boulders, the movement can be 'arrested' and a clear, sharp image will be recorded on the film when using a high shutter speed. This may be desirable in many cases, but sometimes an action shot may have more realism and movement if a lower shutter speed is used and the subject is slightly blurred.

The higher range of shutter speeds is also useful to reduce camera shake. Not many people are able to hand-hold a camera and operate it carefully enough at a shutter speed less than 1/60th without introducing movement that results in the picture being so slightly jarred that it looks out of focus and blurred. Most people prefer higher speeds for photographing children and pets who can never be guaranteed to remain still for any length of time.

The lower shutter speeds allow deliberate blurring of a moving subject for special effects and are also suitable for static subjects like still life, set portrait poses, scenery, architectural pictures and so on.

The aperture and f/numbers

The size of the aperture is controlled by a diaphragm or iris and, like the shutter, a number of different-sized holes can be set according to a scale of numbers that are, again, standardized and universally used. These are called *f/numbers* and a section of this scale will be found on most cameras – f/1.4, f/2, f/2.8, f/4, f/5.6, f/8, f/11, f/16, f/22. the smaller the number, the bigger the aperture. The more the opening is said to be 'stopped down', or made smaller, the less light can get into the camera and vice versa for a set shutter speed.

When a group of light rays from a scene being photographed reaches the lens, and when the lens is focused at infinity, the scene will be displayed on the film as a perfectly sharp, crisp image. In this ideal state, the distance inside the camera between the lens and the film is called the *focal length* of the lens. If the size of the aperture – its diameter – is, say, 1/8th of the distance between the lens and the

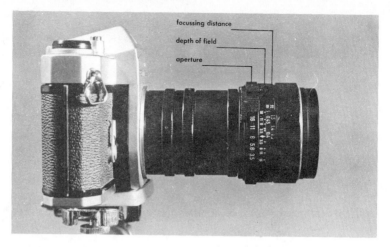

The aperture of this lens is set at f.8. It is focused at 1.3 feet (or 0.4 metres). The depth of field scale shows that subjects lying between 1.3 feet and 1.45 feet will all be in focus. Between the lens and the camera is a set of three extension tubes for close up photography. *(Ivor Hibberd)*

film (the focal length), then the size of the aperture is described as being f/8. If the aperture is 'stopped down' to f/16 the diameter is now 1/16th of the distance between lens and film (focal length). The f/number is a simple way of describing the relationship between the size of the aperture and the focal length of the lens. Fortunately, all camera lenses that have adjustable diaphragms or irises built into their design, no matter what size or power the lens may be, will allow the same intensity of light to pass through to the film when set at the same f/number setting.

A lens is normally identified by its *focal length* (35 mm, 135 mm. etc.) and by an f/number i.e. 50 mm f/1.2. This f/number has nothing really to do with the operation of the diaphragm but indicates the maximum size of aperture the lens has according to its physical construction. For instance some lenses are marked 50 mm f/1.2 or 50 mm f/2. This would indicate that the f/2 lens had a smaller basic aperture than the f/1.2. As more light is capable of getting through the f/1.2 lens it is said to be a 'faster' lens than the f/2 lens and this one would perhaps be more suitable for taking pictures where the light was poor.

Exposure, then, depends upon three factors; the speed of the film, described by an ASA number or a DIN number; the speed of the shutter which can be set to remain open for a determined amount of time and the size of the aperture.

By varying the aperture and compensating by an alteration of the

shutter speed and by focusing the lens carefully another useful pictorial effect can be achieved by considering what is called the 'depth of field'.

Depth of field

An important part of picture-making and composition is to have an idea of how to use the shutter and the aperture together, not only to obtain the correct exposure, but to select which part of the picture is to be in or out of focus. This is particularly true and most effective when using long-focus, (or 'telephoto') lenses of f/135 mm and more. With the aperture wide open, the only subjects in front of the camera that will be sharply in focus are those that lie exactly at the distance from the camera to which the lens has been focused. With the lens focused at a distance of say five metres, only those objects at exactly five metres will be recorded clearly and in focus on the film. Objects in front of and behind that distance will become increasingly out of focus the further they are from the 'focusing plane'. This focusing plane is like imagining a thin sheet of glass at a distance in front of the camera where everything is exactly in focus. If the aperture is closed a little, it is as if the imaginary pane of glass has thickened to a wall of glass, where a greater depth has come into

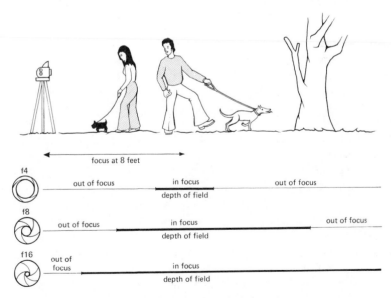

Depth of field – a greater distance is in focus when using a small aperture

focus. With the lens still focused at five metres, the depth may now have increased to a wide band of another four metres behind and two metres in front of the five metre point that was in focus before. As the aperture is increasingly stopped down and made smaller, the depth of the imaginary 'glass wall' increases until, at the smallest aperture, practically the whole scene in front of the camera will be in focus, from a short distance in front of the lens to as far away as can be seen which, curiously, is called infinity.

This band of focus is the 'depth of field' and can be used effectively where the main subject may need to stand out from the background and foreground, like the pretty girl of Chapter 1 who was posed in a field of yellow daffodils in her yellow dress. If she is, say, three metres from the camera, the lens should be focused at three metres. The aperture is then opened so that the background and the foreground is put out of focus. The shutter speed is adjusted to ensure a correct exposure and the result will draw attention to the pretty girl who is clearly focused. The flowers, not being crisp and sharp, demand less attention in the picture.

Using an exposure meter

Bearing in mind what part of the picture is to be in focus (all of it or just a narrow plane) the shutter speed has to be selected to ensure a correct exposure. Camera shake must also be considered if the shutter speed is likely to be below 1/60th. Using a tripod or resting the camera on something solid and steady will allow a lower shutter speed to be used if this is what is required. But how can the correct speed be found for a particular aperture? The instructions provided with each film will give a general indication of the settings to use under average lighting conditions for the speed of the film. For more accurate results, an exposure meter will be useful.

An exposure meter will indicate the precise shutter and aperture combination required for any kind of film under very nearly any lighting condition. Some exposure meters are built-in as part of the camera itself. This system is called 'through-the-lens-metering' (TTL). When viewing the picture through the viewfinder, the meter measures the amount of light in the scene and selects the right shutter speed for a given aperture automatically. On some cameras the shutter speed or aperture controls can be adjusted manually to align a pointer which is seen in the viewfinder.

These meters in the camera often operate by measuring an average of all the light in the picture. Some of them are what are known as 'centre-weighted'. They assume the important part of most

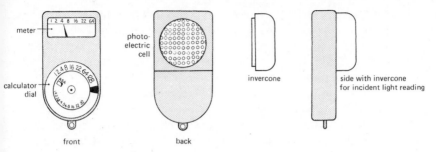

Exposure meter (simplified)

pictures will be centrally placed and the meter measures the amount of light seen in the centre of the viewfinder.

Exposure meters need not be part of the camera and there are several makes that are small, compact and hand held. They all employ one of two basic systems of operation. One type uses a small battery and the other relies upon a photo-electric cell. They both do exactly the same job: they measure light intensity. A calculator attached to the body of the instrument converts the light measurement as a setting for aperture and shutter speed for any film.

An exposure meter may be used in two ways to measure light. The general method is to point it at the scene to be photographed. The light intensity moves a pointer across a scale marked with numbers. The number that the pointer indicates is then set against the calculator from which the shutter and aperture settings can be read off. Pointing the meter at the subject is called a *reflected* light reading. An alternative method is to place a specially designed plastic cover called an 'invercone' over the 'seeing eye' of the meter. The meter is then held at the same position as the subject to be photographed and pointed towards the camera. In this position, the meter now measures the amount of light falling from all directions upon the subject itself. This is called an *incident* light reading and is recommended for all colour photography both indoors and out of doors.

If it is not possible to take measurements for incident light readings because the subject is inaccessible or too far away, the meter with the invercone attached may be taken in front of the camera and pointed towards the lens. A reading is then taken as if it was from the subject itself – provided, of course, the lighting conditions are much the same in both places.

Using the reflected-light method (without the invercone) it is sometimes an advantage to point the meter at the lighter parts and the darker shadows of a subject – and, from the several different

readings, to average them out to one that will suit the picture best. It may be that less exposure is needed for the highlights but more emphasis is to be given to details in the shadowy areas. A single reading of the entire scene by the exposure meter would not be quite so discriminating.

It is always useful, when pointing the meter at a scene, to imagine what it is actually 'seeing'. An extreme example might be that a flag, flying from a flagpole, is to be photographed. Unlike the emotional photographer, the meter is totally unmoved by the flag as a picture and is only concerned about all that brilliant light in the sky behind. If the reading it gives is taken on trust, then the picture will have a perfectly exposed sky; but what about the flag? Clearly an adjustment is needed and a small intelligent guess must be made to compensate if climbing up flagpoles is not exactly possible at the time. The exposure meter has no soul or discrimination; it gives its reading for all the light of a scene, even the light the photographer does not see in his viewfinder – the glare of reflected light from sand and sea or sunlight on white walls. The photographer may need to compensate by pointing the meter at a slight angle downwards to eliminate some of the sky or by taking a series of close-up readings of the subject and averaging out the result.

Meters help the photographer to get closer to the perfect exposure and are well worth possessing since they take out most of the guess-work for most pictures. They are not expensive. Once bought, and if used and cared for properly they can be relied upon, like a watch, to tell as near the truth as they are able for a very long time.

Exposure meters will never give all the answers to exposure questions. Under extremely difficult lighting the meter gives useful information but the photographer is finally left to judge for himself, from his own experience, what exposure will be best for the type of picture he wants.

Bracketing exposures

There is a way out of possible difficulties for that 'never to be repeated' shot, – that once-only picture situation that must be taken properly and that is to take three shots and bracket the exposures. This is, quite simply, to take the picture at the exposure indicated by the meter, then take another at an aperture setting higher and another at an aperture setting lower; 'one up and one down'. This may be an extravagant use of film but if the picture was really worth it in the first place, at least one of the three pictures is likely

to be as near perfectly exposed as possible and the other two not so badly out as to be unacceptable. Three photographs of an important event are far better than one indifferent or totally useless result.

Some suggested exposures

Bonfires. Use flash bulbs or electronic flash unit for faces of spectators. If flash unit can be placed, with a long lead, close to the fire, the light on faces will appear to be from the firelight and more realistic as a result.

Without flash very slow shutter speeds will be needed for firelight. Spectators will be best in silhouette.

Try f/5.6 at half a second with ASA 25 film.

Fireworks. Use tripod and cable release. Select 'B' exposure on shutter setting and set focus to infinity. Judge where fireworks are likely to be in the sky. Open shutter when firework is seen through the viewfinder to explode. Leave shutter open until two or possibly three fireworks have been taken. Close shutter.

Try f/4 for ASA 64

f/8 for ASA 160.

Lightening at night. Use tripod and cable release. Have umbrella handy to protect camera from rain. Select 'B' exposure on shutter setting. Avoid street lamps, lighted windows, etc., in the viewfinder. Set focus to infinity. Choose area in sky where lightening is frequent. Open shutter and allow two or possibly three lightening effects to be taken. Close shutter.

Try f/4 with ASA 64 film

f/8 with ASA 160 film.

Moonlight. Suitable for pictures of churches, ruins, trees, snow scenes, etc.

Use tripod and cable release. Use long focus, telephoto lens for large moon effect. Best pictures obtainable from full moon. Keep shutter speeds as short as possible since the moon moves roughly the distance of its own diameter every two minutes. Maximum shutter speed, ten seconds. Longer than ten seconds will result in a noticeably unsharp picture.

At twilight with some detail discernible and moon in picture.

Try f/5.6 for one second with ASA 64 film

f/4 for 1/5th of a second with ASA 160 film.

After sunset – moon in picture.
Try f/5.6 for two seconds with ASA 64 film
 f/4 for half a second with ASA 160 film.

Pictures illuminated by moonlight without moon in picture.
Try f/4 for five minutes with ASA 64 film
 f/4 for one minute with ASA 160 film.

Mirrors. In a self-portrait using a glass mirror, the focusing distance is from camera to mirror *plus* the distance of mirror to subject.
 Reflections in water are also calculated in the same way. Camera to water surface *plus* distance from water surface to the subject.
 Exposure – open aperture an extra half-stop more than that required for the subject itself.

Dense mist.
Try f/5.6 at 1/60th with ASA 64 film
 f/8 at 1/60th with ASA 160 film.

Light mist. Sun appears as veiled disc.
Try f/8 at 1/125th withASA 64 film
 f/16 at 1/125th with ASA 160 film.

Night Shots. Use tripod, cable release, lens hood. Have torch handy for making adjustments to camera in the dark. Most effective night shots are taken shortly after sunset when some light still in the sky. Light values vary considerably from one scene to another and are best measured by an exposure meter.
Try f/5.6 for ten seconds with ASA 64 film
 f/5.6 for five seconds with ASA 160 film.

Rain. Protect camera and lens from rain with umbrella or find a view-point under shelter.

Dark.
Try f/4 at 1/60th with ASA 64 film
 f/5.6 at 1/60th with ASA 160 film.

Average.
Try f/5.6 at 1/60th with ASA 64 film
 f/8 at 1/60th with ASA 160 film.

Bright.
Try f/8 at 1/60th with ASA 64 film
 f/11 at 1/60th with ASA 160 film.

 Use flash placed to one side for side-lit effect. Try to find a dark background to make rain-drops more effective in the picture.

Rainbows. Slight under-exposure should be aimed for to bring out colours more effectively.

Try f/11 at 1/125th with ASA 64 film
 f/16 at 1/250th with ASA 160 film.

Snow. Choose a bright sunny day for the best snow shots. Side lighting and back lighting give best results. Use lens hood. If using an exposure meter, increase exposure by opening up one stop more than indicated.

Try f/11 at 1/125th for ASA 64 film
 f/16 at 1/250th for ASA 160 film.

Sunrise and Sunset. Use telephoto lens to give large sun. Use tripod, cable release and lens hood. Ensure the sun can be looked at without strain or damage to the eyes. Over exposure softens colours, under exposure enriches colours; red and orange colours are increased. If using an exposure meter, point meter up to sky at an angle of 45° not directly at sun.

Try f/5.6 at 1/125th with ASA 64 film
 f/8 at 1/250th with ASA 160 film.

Light rapidly decreases at sunset and rapidly increases at sunrise. Work fast between exposure meter reading and taking the exposure.

5. Indoor Lighting

Available light

It is a pity that so many amateur photographers only think of their cameras when the sun shines. They are discouraged from the idea of photographing indoors by thoughts of elaborate and expensive lighting equipment and the fuss and bother of setting it up. Many people are daunted, too, by the idea that indoor photography is difficult and something best left to the professional. A visit to an exhibition of the local camera club or a glance through a photographic magazine will show that this is untrue. There are many opportunities for producing good pictures indoors, without going to elaborate or expensive trouble. There is also the consideration that by using lights the photographer himself is in control and not left to the mercies of unpredictable sunshine.

Portraits are probably the most common subject of all indoor photography and some of the most realistic and natural pictures of people and particularly children can be taken indoors without any special lights. An overcast but bright day is ideal, without brilliant sun shining straight into the room to cause hard shadows. To be a little more in control of the lighting, especially when the day is too overcast it is necessary to add light.

Flash cubes and flash bulbs

These provide sufficient light over a reasonable area for most indoor amateur pictures. A few simple cameras cannot be used with flash bulbs. The camera must be synchronized; that is, the flash bulb is fired off automatically only when the shutter is open. Flash bulbs are designed to burn with a very bright white light for a specific length of time and the camera, unless it has only one shutter speed, has a particular speed indicated for use with flash bulbs; generally about 1/30th. There are two types of flash bulbs; clear white bulbs and blue-tinted bulbs. Either of these may be used satisfactorily for black and white photography but the blue-tinted bulbs should always be used with colour films.

Using the guide number

The only successful way of ensuring a correct exposure is to follow the instructions on the packet of bulbs and cubes. This gives a simple table that covers most types of films with different film speeds. If the film speed is ASA 25 and the shutter speed for flash is 1/30th, the table will indicate a number called a guide number. This may perhaps be the number sixty-five. All the time the film is being used with the same flash bulbs this given number, sixty-five, must be carried in the mind. With the shutter speed fixed at 1/30th, exposure must therefore be controlled by the aperture. To decide what aperture has to be selected (f/number), the distance between the flash and the subject is measured in feet. This distance is then divided into the number, sixty-five. Say the distance is sixteen feet from the flash to subject; sixty-five, divided by sixteen is approximately four which becomes f/4. For the same amount of light and a fixed shutter speed of 1/30th, it is obvious that the aperture would be reduced if the flash is taken closer to the subject. If the distance is now four feet then the mental arithmetic becomes sixty-five divided by four – sixteen (near enough) which becomes f/16, a much smaller aperture than f/4 at a distance of sixteen feet.

Electronic Flash

The advantage of the electronic flash over the flash bulb and flash cubes is its ability to produce a flash of bright white light several hundred times. Electronic flash units are powered by small electric batteries or rechargeable nickel-cadmium batteries or by the normal mains electricity. Almost all flash-unit power supplies have to be recharged or the batteries changed after two hundred or so flashes. Most flash units are small, light and easy to carry. Their main advantage is that the light they give out is of the same kind as strong sunshine and can be used with black-and-white and daylight colour film.

The speed of the flash is very much faster than that of flash bulbs; anything from 1/500th second to something like 1/32,000. It is, of course, necessary for the shutter of the camera to be open when the flash fires. Cameras that are synchronized for bulb or electronic flash generally have a switch indicating the type of flash unit that should be selected. For flash bulbs, which incidentally burn brightly for a longer period than electronic flash, a slow shutter speed is indicated, usually about 1/30th second.

When the shutter release is pressed, the shutter opens first, the

flash bulb is automatically fired, then the shutter closes. The same is true for electronic flash, but as the duration of the light is much shorter, the preferred shutter speed may be faster – usually 1/125th second. Calculating the correct exposure is done in exactly the same manner as for the flash bulb; from a guide number for a particular film speed: dividing the overall distance between flash and subject in feet, into the guide number.

Automatic flash units, sometimes referred to as computerized units, make correct exposure much easier. From a calculator on the back of the unit, the aperture of the camera is set to the film speed being used. The distance from flash and subject is also set. With the shutter speed set to the synchronized speed recommended for the camera, the only variable that can be adjusted to achieve a proper exposure must be the amount of light emitted by the flash unit. As the flash sends out its light, so some of it will be reflected back towards the flash unit. This reflected light enters a small hole in the front of the unit which is measured by a sensor cell and automatically switches off the flash of light when the subject has had the correct amount of light.

Several flash units may be used simultaneously in lighting a portrait. Using one flash indoors for a portrait or a 'candid' shot, the unit is usually kept attached to the camera itself, giving full frontal lighting. More often than not this produces flat, washed-out puddings of faces in the picture with hard black shadows on the wall behind. If it is possible to detach the flash unit from the camera, a better picture can be made by holding the flash high above the camera and as far to one side as the arm will allow. If this can be done with the help of an assistant so much the better and the resultant picture will bring out the features and the roundness of the model's face to advantage and the shadows behind will be placed to one side. Direct flash is often hard and unflattering on the model because of the harsh light and shade produced in the picture. Frequently the flash will give brilliant illumination to foreground objects but leave the background very dark indeed.

Bounce flash

To overcome harsh contrast and to introduce the natural half-tones that give a truer, more three-dimensional characteristic to a subject, it is better to reflect the flash light off a white ceiling or a light-coloured wall on to the model. This requires an alteration to the exposure calculations because the whole of the light path from the flash unit to the ceiling or wall and from the ceiling or wall to the

model has to be measured in feet. It is this figure that now has to be divided into the guide number. Having discovered the f/number, the aperture must be opened one or perhaps two further stops to take into account the amount of light from the flash that is not reflected on to the model by the ceiling or wall.

With colour film, the ceiling or wall must be as white as possible If the wall has coloured wallpaper, the light from the flash unit will, as it were, carry the colour in its light and give a very distinct colour-cast to the model which may be unnatural and discouraging.

Watch out for those other reflecting surfaces like windows, mirrors, or shiny furniture that will reflect the flash straight back into the lens and spoil the picture with a splash of light. One or two thicknesses of a clean white handkerchief or a thin white paper tissue held over the flash unit will diffuse the light, soften the harsh effect and spread the light over a much wider area and a shorter distance. Exposure under these circumstances must be largely guesswork, based on experience, but if the picture is repeatable it is well worth taking two shots of the scene for safety; one at the exposure it ought to be and another with the aperture opened one or two stops.

Special lighting

Ordinary household lights can be used for indoor work but they are not usually powerful enough to use except with very slow shutter speeds. There are electric light bulbs made specially for the indoor photographer known as photoflood lights. These bulbs are made as if they were intended to be used on an electricity supply much lower than the normal mains voltage. When in use they are 'overrated' and burn very brightly indeed though only for a few hours compared with the normal electric light bulb. They also get very hot and only a few moments after being switched on it is not possible to touch them by hand. For this reason it is advisable to use these bulbs in metal sockets rather than plastic or bakelite holders which will scorch, smell and become very brittle.

Photoflood lights are intended to be used in metal lampholders, complete with extending tripod stands and metal reflectors. These are not expensive and well worth having if you intend to do a fair amount of indoor photography. Without the stands, it is possible in an emergency to use a photoflood lamp in a table lamp. Always remove the lampshade. This prevents both scorching and colour from the shade being cast on the model when using colour film.

Think of the lamp as the main light source and place it in a position which imitates a natural source. If it is taking the place of

light shining through the window, the lamp needs to be diffused by hanging a white net curtain or a piece of white gauze between the lamp (not too close, at least a metre away) and the model, placed at least another two metres away from the curtain. Outside daylight comes in through the window at an angle; to achieve this effect the lamp should be placed behind the net curtain or gauze higher than the model.

Never place the photoflood lighting too close to the subject, particularly in a portrait. It is not exactly true that the more light on the subject the better. To get close with lighting is to create some areas that will be very over-lit. Harsh, dark shadows look unattractive and unrealistic in a portrait. A lamp should seldom be less than one and a half metres from a model.

Photoflood bulbs are by no means the true alternative to sunshine and if normal daylight colour film is being used, the results are very disappointing. They will have a yellow/orange cast and look very peculiar. Two remedies are available; one is to buy a film that is specially made for use in artificial tungsten lights, referred to as 'professional' film; the other is to obtain a special blue lens filter which will have the effect of turning a normal daylight colour film into a special artificial light film. The results will be so nearly natural that any slight discrepancy in colour will be hard to detect.

The intensity of artificial light, bright as it may seem, is greatly inferior to sunshine and exposure is difficult to judge just by looking at the scene. Photofloods are available for home use in two powers 250 w and 500 w. Each lamp comes with instructions on calculating the correct exposure for the particular lamp used. No more than three lamps should normally be used on one fused output socket of a room in the house and there is seldom need to use more than three lamps for most interior pictures.

The amount of light they give can be measured by the normal exposure meter using the reflected light method (pointing it at the subject), or, if using colour film, by the incident light method (using an invercone).

Quartz-iodine is another type of tungsten lighting used in just the same way as photoflood bulbs but somewhat more expensive. These give more light for less power and last a great deal longer than the photoflood. They also tend to get very hot indeed in use. It is advisable to keep a cautionary eye open when using either photoflood or quartz-iodine, if young children are about. With children, the quite harmless flash equipment is a better prospect in many ways.

Taking pictures indoors

Given a tripod, a few lights and enough elbow room in which to work, there is plenty to be photographed indoors all the year round, particularly during the dark winter evenings. Some of the best-known photographers work in simple studio accommodation no larger than an average living room. Their equipment is often no more sophisticated than that of the keen amateur. In fact, the simpler the set-up, the better the results in most cases.

Formal portraits

A roll of 'background paper' is always a useful prop. Different colours may be obtained through photographic dealers or by mail order. It is generally enough to start with a light blue and a black for both colour and monochrome films. Rolls of background paper are cheap and usually about three metres wide and nine metres long.

The roll is fixed high up, over the curtain rail or picture rail perhaps, and hung straight down to the floor for a three-quarter-length portrait and curved forward from the wall along the floor, without a crease, for a full-length picture.

The advantages of using a roll of paper are that the background will be smooth, without unsightly creases and a full-length picture will have a feeling of space behind the subject being photographed – quite apart from covering over the wallpaper, the skirting board and the pictures on the wall behind.

A white bed-sheet or a grey blanket are possible substitutes for half-length portraits but beware of creases and folds that may be unsightly in the final picture. A plain light-coloured wall is also very suitable for head-and-shoulder portraits.

Setting up

Sit the model on a kitchen stool. High-backed chairs and deep armchairs make it difficult for the model to move position and usually make unattractive backgrounds immediately behind the model's head. Place the stool as far from the plain background as possible without seeing the edges of the backing paper or other unwanted bits and pieces in the viewfinder.

The camera should preferably be set up on its tripod with a cable release attached, since shutter speeds are likely to be slow and camera shake may be introduced. There is no great benefit to be had in rushing about with hand-held camera shooting off rolls of film from

every angle. This may look highly professional but it is a costly way of getting results. The model is virtually stationary; the picture composition is under the photographer's control. There is no need to hurry as long as the model is warm and comfortable. There is plenty of time to study the picture in the viewfinder, and to check the exposure. The sitter may be tempted to think it is a lot of fuss and bother but invariably this is forgotten when the finished result is presented and admired later.

Lighting: daylight

Daylight, streaming in from a window from a bright but overcast day is probably one of the best forms of lighting for portraits. It is a natural light much favoured by professional portraitists. It is also the cheapest .

If it is not possible to sit the model away from bright shafts of sunshine, diffuse the rays by a lace curtain or gauze placed between the model and the window.

A sheet of newspaper or a white bedsheet held up to the reflect daylight back on to the shadow side of the model will fill in more detail and give a more natural result. It will also reduce the contrast between the highly lit areas on one side and the dark shadow areas of the picture on the other.

Photofloods

Start by attempting to create a natural portrait; creative effects can be attempted later. Seat the model comfortably. The camera should be at roughly the same height as the model's head for a head and shoulders picture. If it is too high, the nose will appear elongated; if it is too low, the chin will appear to be exaggerated. One light, the main light, should be placed to one side of the camera fairly high up and not closer to the sitter than one and a half metres. If a line was drawn from the model to the camera, the main light would be about 45° from the model. If another line was projected upwards from the model to the ceiling the height of the main lamp would be at an angle of about 45° to the model. This 'double 45°' is an easy rule-of-thumb for remembering the setting for the main light. The lighting effect on the model's face should now produce one side of the face fully lit and most of the other side in shadow. On the shadow side the cheek-bone will be lit under the eye in the form of a triangle. Watch for the hard shadow cast by the nose on to the upper lip. This shadow should very nearly extend to the lips of the model's mouth,

Light from the window gives a soft and natural effect to indoor portraits.
(Roy Hayward)

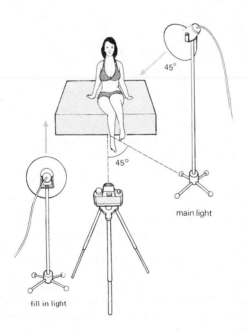

main light

fill in light

Basic portrait lighting – the double 45°

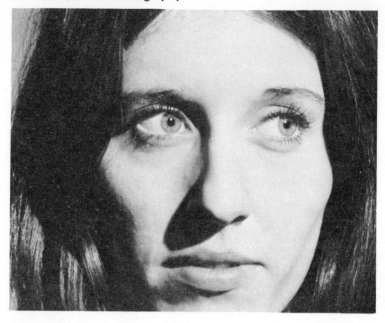

The main light should cast a shadow of the nose across the upper lip.
(Roy Hayward)

but not be so long as to cross the lips and spill on to the chin. By
adjusting the height of the main light this shadow can be lengthened
and shortened. This lighting roughly represents normal sunshine.

A picture with this lighting would not flatter the model. The light
and shadow would be too severe. Soften the shadows by using a
reflector, (a sheet of newspaper or a white cloth), to cast back some
of the light into the shadows. Better still is the use of a second lamp –
the fill-in light.

The fill-in light

This is usually a lower-powered, more diffused light. It is placed at
the other side of the camera to the main light but as close to the camera
as is convenient. Its height should be a little lower than the main
light and shine full at the sitter.

Watch, again, for the nose shadow. It should not disappear
altogether when the fill-in lamp is switched on. If it does disappear,
the light is too close or the lamp too powerful. Move the lamp back
until the nose shadow is just noticeable but weak.

The main light should be about four times stronger than the fill-in

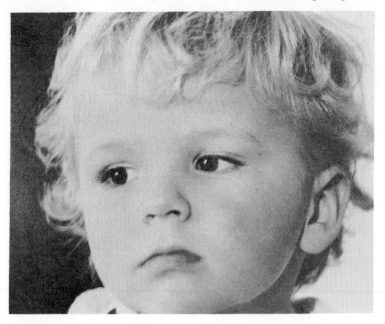

When main and fill-in lights are properly balanced, shadows are softened and the head of the subject has a natural, rounded, three-dimensional appearance. *(Roy Hayward)*

light. This arrangement will produce perfectly adequate, natural pictures.

Elaborations: Lights for effect

Adding more lights will not necessarily improve the lighting of the model's features, but an extra lamp, shining straight down from the ceiling on to the head of the sitter, will illuminate hair, giving it a lifelike softness. This lamp should be very slightly behind the model: take care not to spill the light on to the forehead or top of the nose.

Another light placed on the floor behind the sitter and directed towards the background paper will give a clean, distant effect to the background. A small branch of leaves or a patterned cutout in front of this background light will produce interesting shadow patterns that may well improve the picture.

If the model is wearing spectacles, a common problem with this basic lighting technique is a brilliant reflection of one of the lights. Always check by looking through the viewfinder. To get rid of a reflection requires only the slightest adjustment and this may be done by moving the camera a fraction higher or lower or to one side

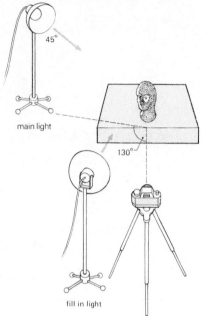

Rembrandt lighting

or another. Usually the culprit is the fill-in light and lifting it a couple of inches up or down will generally deal with the problem very easily.

Rembrandt lighting

This lighting, as its name implies, was used by the painter to good and lasting effect and produces a dramatic – even glamourized result. The sitter is turned profile to the camera. The main light is placed behind the model at about 130° to the camera position and at a height of 45° as before.

By careful adjustment, the light will illuminate the forehead and rim-light the line of the nose, lips and chin. Watch particularly for a triangle of light on the cheek nearest the camera. There should also be light in the eye and on the eyebrow.

In setting up this lighting effect, it is usually best to get the sitter to adopt a general head position and then fix the light. Once it has been set in more or less the right position, the model may be persuaded to move into the exact position for the picture.

Rembrandt lighting gives a dramatic and artistic effect to a subject.
(Ivor Hibberd)

A weak fill-in lamp may also be used from its previous position near the camera to fill in some of the shadow but quite often a good dramatic picture may be produced without it. Take great care as always not to get lights too close to the model or the final picture will have 'burnt out' highlights and be very 'contrasty'. Always err on the side of placing lights a fraction too far away.

Children and pets

On the whole it is better not to pose these subjects but to capture natural expressions, unexpectedly. Posing for a picture can so often produce a tense, uncomfortable result. This applies particularly to children and pets who can seldom be expected to co-operate with sustained enthusiasm or remain in one position for very long. A photographer can seldom win by perseverance or bribery.

One way to overcome the problem is to diffuse a floodlight by directing it up to a white ceiling or to use a wide reflector lamp, set fairly high up and pointed downwards to illuminate a fairly large working area. Look to see where the shadows may appear and fill-in

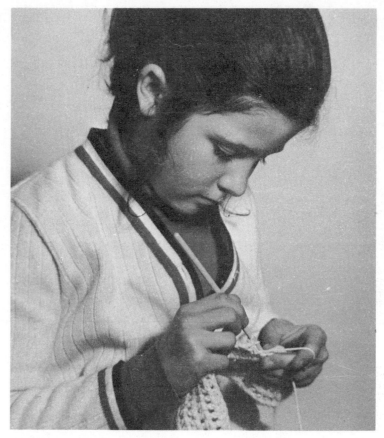

Children are best photographed when engrossed in something that interests them. *(Roy Hayward)*

with another diffused lamp of slightly lower strength. Having lit the area, get the child to be occupied with something that commands interest; watching television, reading, painting, playing with a toy, or talking to someone just outside the picture. Do not distract the child by talking or trying to create a co-operative rapport. Ignore him completely and then snap when the subject seems to be worth taking.

Dogs and cats are better approached after they have had a meal or tired out after an outing. Like human beings they are more comfortable, more relaxed and less likely to be distracted. Again, the well-lit area, with its near-natural lighting effect used for children, may be profitable for the most natural pictures.

As before, the pet should be snapped in a normal characteristic

pose; the cat washing itself, the dog feigning sleep with one eye open. With children and pets, the camera viewpoint should preferably be at the level of the subject; even lying on the ground if this can be done without creating a great disturbance and astonishment all round. The adult-eye view, looking down from about five feet, seldom produces an attractive picture. Children and animals are usually very quick even if their movements are small. To arrest this movement and prevent a blurred result it is generally better to use a flash unit.

Babies

Bounced flash is the best for young babies. The diffused light from the flash unit is kinder to their eyes than direct flash or floodlights. Watch out for coloured ceilings and walls when using colour film. To the camera, most young babies are basically little coloured faces surrounded by a cloud of soft white material and exposure has to be carefully controlled to ensure that the mass of white in the picture does not produce a false exposure that gives an under-exposed face. Open the aperture at least half a stop to give proper exposure to the face and the swaddling clothes will take care of themselves.

Parties

Flash is the most effective lighting for parties.

Always have a thought for the background when taking an indoor candid snapshot with flash. Windows, mirrors and highly polished furniture will seem to reflect light back into the lens from every possible angle and spoil the effect. The answer is to get fairly close and try to fill the frame with the subject, cutting out as much of the background as possible.

Even so, a quick look around the room may suggest a safe and suitable background and several pictures may be taken pointing the camera and flash in that direction.

Children's parties can be chaotic and fast-moving affairs. It is not very fruitful to charge around snapping and popping off flash bulbs in the hope of getting a marvellous action picture. It is best to wait for a rest period, a sitting-down game or the tea table.

It can also be an attractive and welcome novelty at a party, for very young children to have a special party portrait taken. Set up the lighting in a room, away from the party, well before it is due to start using the basic portrait lighting plan. Check focus and exposure and leave it all set up until the time comes and the children start to arrive. Take them one at a time. They are usually spick,

span and spruce at this stage and also on their best behaviour – all of which will certainly deteriorate as the party progresses.

Close-up and table-top

Many interesting pictures can be attempted on the table-top without elaborate equipment: flower arrangements, insects, glassware, collector's items, and creative abstracts. To get the best out of any table-top subject always use a cable release with the camera mounted on a tripod. The picture needs to fill the frame and for this the single-lens reflex is ideal. With a standard lens of about 50–55 mm, the closest distance for focusing an object properly may be about eighteen inches, measured from the film itself, not the front of the lens and this will give many opportunities for experiments with close-up.

To obtain a greater degree of magnification and a closer effect, a simple close-up lens placed over the front of the camera's lens will be necessary. These are not expensive and bring a great deal of additional interest to home photography. The stronger the close-up lens, the closer the camera can get and the larger the picture in the frame becomes but the quality and definition suffers a little as the magnification increases. For more serious close-up work, extension tubes may be used.

These are metal tubes of different lengths fitted between the camera and the lens. In effect, they place the lens further away from the film in the camera and increase the magnification of the picture. Tubes of different lengths may be used singly or in combination.

An alternative to tubes is the variable bellows unit which is similarly placed between the camera and the lens. With this unit the lens can be made to move backwards and forwards, closer to or further from the object giving a wide choice of magnification. Bellows are quite expensive but well worth buying if close-up photography becomes an absorbing interest.

Using bellows, the camera should be mounted on the tripod and a cable release used for the shutter.

Since the light from the subject has further to travel from the lens to the film when using extension tubes and bellows, the exposure must be increased by opening the aperture one or two stops according to the distance the lens has been extended. Tables are provided to calculate the additional increase in exposure and these are usually provided with the extension equipment.

When taking any close-up, the depth of field is generally very shallow indeed, only a millimetre or two at most unless the lens is

stopped down to its smallest aperture. This means compensating by a slower shutter speed (hence the tripod) and very strong lighting. Direct flash placed close to the subject results in a shiny, plastic effect which will look artificial. This is particularly true of a shiny object like a beetle or a leaf and is best overcome by diffusing the light with a white handkerchief or tissue paper over the flash unit.

Lighting from the side of the object will emphasize texture and surface detail and will also give a more three-dimensional effect to a round object. Take care that no strong reflections appear in the lens from shiny objects like glass, porcelain or metal.

A slide projector can easily and very effectively be used as a light source. With no slide in the projector the width of the beam of light can be narrowed by cutting a piece of cardboard to the size of a slide and making a hole or a slit or a star in the centre and projecting through it. This can be used as a spotlight or a general floodlight and is also very useful for producing background shapes and effects to formal portraits.

A great deal of interest can be had in colour photography at the table-top by using coloured gelatine over the lights, and creating different effects on quite ordinary objects. Try glassware, with a black background, lit from one side by a blue light and from the other side by a white light.

Try a flower arrangement lit by a white light at 45° (like a portrait), but for a background use a roll of kitchen tin foil, crumpled up and opened again, creased and crinkly and lit at a tight angle from the other side, by a projector with a coloured sweet paper over the front of the lens. If this background is put out of focus by suitable depth-of-field focusing the effect will be very interesting.

Try photographing a cut-glass ashtray, lit from the rear by a projector and shoot through a large hand magnifying glass. Change the colour of the light by putting slides into the projector. The results can be quite unusual and are bound to create comment.

6. Taking Pictures Out of Doors

Loading and unloading the camera

Always load any film 'fast' or 'slow', in the shade so that strong sunlight does not penetrate the protective paper backing of the film or find its way into the light-tight cassette or cartridge. If a roll of film comes back from the processors with streaks at the edges of each frame or if the first few pictures on the roll are streaky or over-exposed it is a sign that light has penetrated during loading or unloading. Even if there is no convenient shelter, the loading and unloading operation can usually be done in the shadow with ones body between the sun and the camera. Keep out of the wind, too, while the camera is open to avoid very fine dust getting into the works. A tiny grain of sand can jam the shutter or affect the aperture on some cameras. Also, if a grain gets stuck inside somewhere, just where the film will pass over it during winding-on, there will be a perfectly etched scratch-line, right across every picture. It is always best to load and unload a film indoors. A gentle blow inside the camera with a special camera blower brush when a new film is loaded and a light polish-up over the body work with a soft duster every now and again are sufficient to keep the equipment in good order for several years.

After a film contained in a cassette has been exposed, it has to be rewound back into its light-proof cassette before it can be taken out of the camera. Cameras that use these cassettes have a rewinding handle and a spool-release button for this purpose. It is usually a great help to the processors that the leading end – the tongue of the film – should not be wound back completely into the cassette but left hanging out in the same manner as it was when the film was bought. When winding the exposed film back in the camera it's a good idea to listen for the leading tongue slipping out of the take-up spool. When this happens, the camera may be opened safely and the free end of the film hanging out of the cassette should then be bent back with a good crease, wrapped around the outside of the cassette and put into the little tin it came in – all done in the shade, of course. This hard crease on the film will prevent confusing an unexposed film with an exposed one, as no new film will have a hard crease line on

the leader. Not only is this useful in daylight but it can be even more valuable when working in the dark.

Composition

Everybody has his own reasons for wanting to photograph a subject whether it be a view, a member of the family or an object, and for most people it is enough for the picture to 'come out' nicely with a technical competence that makes the picture recognizable and 'just as I remember taking it'.

But what makes one photograph more appealing than another? Picture composition can be reduced to a set of rules and, theoretically if these rules were followed to the letter, a perfectly composed 'winner' would result every time. Unfortunately, as we all know, three or maybe four really good pictures on a roll of film is good going for any creative and conscientious amateur.

If the photographer goes entirely by a set of composition rules the results will most likely be competent, but only on very rare occasions will there be a remarkable, exciting picture that stands out from all the others.

The element that makes the successful picture more appealing and more interesting to the viewer is a quality of composition introduced by the imagination of the photographer. It is something of his own; a personal imprint that gives the picture a special character that will mark it out from a picture photographed by any other photographer – even of the same subject.

Some photographers exploit the potential of colour; some use depth of field to the extremes or exaggerate close-ups; some pictures are purposely blurred and unsharp; shots are taken right into the sunshine to capitalize on bubbles and streaks of flare across the film.

Creative pictures like these are neither the result of following a set of rules nor happy results from total incompetence. They are products of a photographer's imaginative use of equipment; of knowing the rules and either adding to them or wilfully breaking them for well-considered reasons.

The unwritten rules of composition rely largely upon what most people would collectively and traditionally consider to be a pleasing and effective picture and most people's judgement of what is pleasing and effective has been conditioned by centuries of painting.

Imagine the picture area divided by lines into three vertical sections, a middle and two sides, and horizontally with a middle and top and bottom section. The most important parts of the picture, visually, can be said to be at the four points at which the lines inter-

main subject of interest is usually best if placed on the thirds —
not the centre or near the frame edge

sect. Generally speaking, if the main subject of the picture is placed at any of these four points ('on the thirds') it will appear to be more effective and a far more pleasing composition than placed slap in the centre.

If the head of a portrait is placed at the third to either side of the centre, it is generally more acceptable for the head to be turned so that it is looking into the picture across the open space of the picture area. This is true of moving subjects like animals, people, cars and boats. They should give the impression of being part of the picture and not just about to leave it in a hurry.

Horizontal lines and vertical lines should preferably be placed off-centre to avoid a division into equal halves. The trunk of a tree, the horizon in a beach or pastoral scene are often better if placed on the thirds. All horizons should be level, all verticals should be upright unless there are good reasons for them not being so. There is nothing more disturbing in a sea picture than a tilted horizon, with the sea appearing to pour out of the picture on one side or the other. If a sky has interesting, moody clouds, choose a low point of view to have two thirds of the picture area dominated by the sky. If, on the other hand, the sky is plain, grey and uninteresting, choose a higher point of view and look down on the main subject to reduce the sky area or eliminate it altogether. Always watch out for lamp-posts, telegraph poles and any hard, straight verticals that may appear in a scene. They can often divide the picture into unwanted parts. If they are in the background they may appear to grow out of the head of a person being photographed in the foreground.

Diagonal lines in a composition are usually strong and dramatic. They emphasize perspective and convey depth but are usually better

placed above or below the centre point of the picture to avoid cutting the picture into two triangular parts.

A triangular composition can often be used to good effect, especially when photographing three people in a formal portrait, although other more general subjects can be so arranged in the viewfinder to form a triangular pattern.

The frame of the picture is a danger zone. Take great care that the frame does not amputate hands, legs, and parts of the head in an abrupt and uncomfortable way. All that the picture is meant to convey should be within the frame and seldom, if ever, should the viewer be imagining what lies outside the edge of the picture. A snapshot, quickly taken, may be a good action shot of a member of the family doing something interesting. It should not be taken so quickly that a pair of unnoticed, anonymous feet stick into the picture at the bottom left-hand corner.

In spite of the important areas on the thirds which claim the eye's attention, any written words in a picture, notice boards, hoardings, grafitti, no matter where they are placed in the frame, will command interest. This may be an advantage where the writing forms the main part of the picture but it is a disaster if it is irrelevant to the scene. It is even worse if only half of the writing is in the picture and the rest is cut off by the edge.

Colour is important. The blues, particularly pale blues, are 'receding' colours that give depth to a scene while reds call attention to the eye. One tiny spot of bright red in a scene that is largely pale green or blue will be dominant out of all proportion to its size. This can be used to advantage. A figure of small size placed appropriately in, say, a mountain scene can give proportion and a necessary human element if the figure is wearing a red anorak or a red woollen sweater. It would be a disadvantage if the figure is not placed in the correct position and the red anorak, because of its demanding colour, dominated the scene out of all proportion.

The relationship of one colour to another can play an important part in producing a pleasant result. The variety of primary colours to be found at a fairground, a fruit stall, in the market place, a balloon seller, will all be striking, alive and characteristic of the mood of the scene, but for quieter more peaceful moods the pastel colours and a minimum of primary colours will be preferable.

All good composition is based on selection. What the eyes see may be a mass of chaotic impressions, but, by careful examination, the essentials can often be selected and arranged within the frame by using a different lens; by changing the viewpoint; by moving closer or further away and filling the picture area with essentials only.

Developing an awareness for pictures can be an engaging habit in daily life. It is surprising how little one really sees and how much is taken for granted and left unobserved, particularly in familiar surroundings. The French photographer Latigue describes how, as a young boy before he possessed his first camera, he would open and close his eyes quickly and 'photograph' in his mind what he saw and this he claimed helped him to appreciate good pictorial composition.

Any appealing picture would normally have some obvious or recognizable order about it. It would suggest to the viewer that the photographer had given consideration to composition before he took it. A formal portrait, for instance, would convey an understanding to the viewer of the kind of person portrayed and not just a 'good likeness' suitable for a passport.

A landscape, a seascape, a general view, may need to be recognizable, but the result need not be just another picture postcard taken on a bright sunny day. Why not an early-morning or late-evening shot with a companion included somewhere in the picture.

It is also important to develop sensitivity to mood, and atmosphere and the effects of good and bad weather on an outdoor scene. A single wind-bent tree on an open moor would suggest a mood quite different from waves beating on rocks in a gale, or sheep grazing in a sunlit valley. Mood and atmosphere can be conveyed by choosing the right lighting effect, the right weather conditions and the arrangement of main subjects within the picture area.

Many people have been brought up to use a camera with the sun shining over their shoulder and although this may to some extent simplify the lighting of the subject, there are more interesting alternative ways of using even simple cameras in bright sunshine. Side lighting, with the sun at 90° to the subject can bring out surface details and texture. Pointing the camera very nearly straight into the sun can produce most interesting 'back lit' effects characterized by a silhouetted subject, rimmed by light. Sunshine penetrating through leaves or a girl's hair enhances what might otherwise be rather ordinary pictures. Under these circumstances the exposure requires adjustment and since more light will be entering the camera the aperture needs to be stopped down or the shutter speed increased.

An important warning has to be made when pointing the camera towards the sun. Never view bright sun through the viewfinder; it is definitely harmful to the eyes except for sunrise and sunset pictures when the strength of the sun is weaker and less dangerous.

As a general rule the main subject should occupy a reasonably large part of the picture space. A picture of a child playing on the

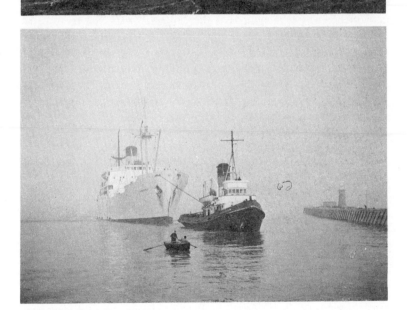

Wind on the sea and late afternoon sunshine emphasise the atmosphere in a realistic way. *(Harold Breton)*

Early morning haze and a calm sea suggest a special mood in contrast to the previous picture. *(Harold Breton)*

lawn should not result in a picture of the lawn with the child barely visible across monotonous acres of green grass.

Trying to get the whole of a tall building into the frame can present difficulties. Short of moving back about a quarter of a mile, the tendency is to tilt the camera upwards but the result of this is often disappointing. The building in the picture will appear to be leaning backwards in an unrealistic and alarming fashion. If tilting the camera seems to be the only reasonable way of photographing the building, it is sometimes worth considering the possibility of going in really close and shooting almost vertically upwards. The result will certainly be dramatic, giving emphasis to its dominance and height.

Subjects that move

The golden rule of keeping the camera rock steady when the shutter is released is one of the rules that is best broken when taking pictures of moving subjects. As a runner breasts the finishing tape at the end of the race, what is it that the camera is expected to record? Is it a crisp picture of the winner, complete with facial expression that stands out by its very sharpness from a blurred background? Or is it to be a well-defined background of judges, crowd and the grandstand behind, with the winner, unrecognizable as a blurred moving object smeared across the picture? Both of these possibilities may be valid. To emphasize the atmosphere of the occasion the first may be preferred. It can only be obtained by moving the camera as the shutter is released.

Panning with the movement

The runner is lined up in the viewfinder and focused properly as he approaches. Select aperture and a fairly fast shutter speed. As the runner passes the camera position at the finishing line turn your whole body – not just your head – to keep the runner in the viewfinder. At precisely the right moment, when the runner breaks the finishing tape, press the shutter. It is important to remember that if your turning action is correct, you will continue to turn after the picture has been taken. This body action is a smooth, continuous movement, complete with a follow-through after the shot has been taken.

The shutter speed does not have to be correspondingly higher for really high-speed action like motor racing. Quite simple cameras with only one shutter speed can be used to capture fast moving

Pointing the camera towards the sun brings out the texture of a subject to advantage. *(David Simpson)*

Snow scenes are usually best taken with the sunshine coming from the side to emphasise the shadows and textures. *(David Simpson)*

subjects if the camera is panned smoothly and the shutter button pressed properly and not 'jabbed' suddenly in the excitement of the occasion.

One of the great difficulties is to get the subject in focus at the split second when the picture is taken. With simple cameras the depth of focus is generally deep enough to give a sharp result at, say, f/8 providing the subject is neither too close nor too far away. With cameras where the lens has to be focused, it is often a question of judgement how far away the subject will be at the moment of exposure. It is a good idea to look out for any convenient aid.

At a motor race, for instance, look out for an oil stain on the track that may be just the right distance to focus on before the cars arrive. At show jumping, avoid getting exactly in line with the jump. A side-on shot may not be as good as the picture immediately after the jump has taken place, with the horse and rider approaching the camera. Focus on a point midway between the two sides of the jump where the horse and rider are likely to be photographed at the best moment in their action. More often than not there is a fixed point

Panning the camera captures a moving subject sharply in focus leaving the background blurred. Note that the impression is that the boat has *arrived* in the picture – it is not just *leaving* the picture. *(Ivor Hibberd)*

on which to focus. Having found this you can give your whole attention to keeping the subject in the viewfinder during the jump without unnecessary panning.

Subjects in motion are moving faster in relation to the camera when passing side on, than when approaching head on, but even in this case composition still plays an important part.

The moving subject should appear to be entering the frame with more space in front than behind, giving the impression that the photographer pressed the shutter button as the subject came into the picture rather than suggesting he just managed to catch the subject before it disappeared completely.

Freezing the action

In action pictures there is also a danger in using a very fast shutter speed that freezes all the movement. This can sometimes create an unrealistic result. It is sometimes an advantage to select a slower shutter speed and introduce a little blurring to produce an illusion of the subject in movement. When recording a waterfall where water cascades dramatically there is the danger again of using too fast a shutter speed. The result is often disappointing, making the water look plastic, frozen and 'not wet enough'. A speed of 1/125th may generally be found to be fast enough to give a more natural, wet and watery effect.

Using flash out-of-doors

Flash does not have to be restricted to indoor photography. There are times when the light outdoors needs a little help. Dark corners, under archways, under trees, filling in detail in the shadows, are typical situations where additional light will improve the picture. 'Fill in' flash can be most effective and if handled with subtlety, will create natural-looking pictures that sometimes seem better than the original live situation.

Calculating the exposure can be a little more difficult but a rule of thumb would be to set the camera in the normal way as if for a daylight picture without a flash but stop down (making the aperture smaller) by one further stop.

Flash is also useful outdoors for photographing close-ups of flowers or insects, but again the harsh light is so different from the sunshine or diffused light on an overcast but bright day that it will give a 'plastic' appearance to shiny objects like berries and leaves. A tissue or handkerchief will help here. Bear in mind that the flash is usually taking the place of the sun so the flash unit should be held above and a little to the side of the subject for a natural result. The speed of the flash is so fast that it will arrest movement and this, too, is a help in photographing close-ups of flowers out-of-doors when the slightest movement from a breeze may throw the picture out of focus. Photographing insects out-of-doors in their natural environment with flash is much to be preferred to carrying them indoors and giving them a hot time under photofloods.

The improvised tripod

There are times when the tripod has been left behind and the exposure demands a very low shutter speed. Very few people can guarantee a shake-free picture at speeds longer than 1/60th second and if the exposure requires anything longer than that the camera must be supported.

Obviously it can be rested upon a wall or a chair or anything that is firm and flat, but if, as so frequently happens, there is no convenient flat surface, it may be possible to hold it firmly up against the side of a wall or a tree-trunk. A walking stick or a stiff branch of a tree can be used as a makeshift mono-pod which will certainly cut out an up-and-down movement, leaving the camera operator to concentrate on steadying the side-to-side movement.

A long piece of string fixed to the camera at one end with an odd piece of stick tied to the other end can also be turned into a

mono-pod. The string is wound up on the stick until the length of the string is equal to the distance from the ground to the eye-level of the camera. The stick is held firmly on the ground under the feet and the string pulled up taut by the camera. This too will eliminate an up-and-down movement as long as the string is kept taut. Cameras with neck-straps can be held by one hand and tightened to hold the camera firmly against the cheek-bone and forehead. If the photographer has braced himself against something firm, reasonably show shutter speeds can be held fairly well. For time-exposures requiring more than a half second it is generally best to have no physical contact with the camera except through a cable release.

Getting the 'extra' picture

The camera is often used to record 'once only' situations: the moment when a baby is christened: the bride and groom driving away to the honeymoon: the family group posed for a special occasion. There is every reason here to ensure the picture is successful. The event and the personal responsibility involved may be overwhelming but very often, the moment the picture has been taken, there is a general relaxation all round. Everyone says to himself 'Thank goodness that is all over'. That is the moment when the photographer should be the most keenly aware of picture possibilities; watching for reactions that are natural and spontaneous which can add a real and live meaning to an otherwise 'set piece'.

Is it art?

Taken to its limit, a photographer selects, arranges, conveys a mood, abstracts the essential, and projects a meaning to his picture just as a painter does. But unlike the painter who has ample time to consider the overall effect of his painting and to make alterations here and there to correct his balance of shapes and colours, the photographer must, generally speaking, work much faster; more intuitively. The photographer relies on altering his viewpoint; moving closer to or further away from the subject; using different lens of different focal length; raising or lowering his camera height; adjusting the depth of field and determining his exposure time. Having done all these things rapidly to his satisfaction, he commits his picture in the fraction of a second the shutter is operated. Although prints may continue to be worked on at printing stage in the darkroom, many successful photographs are the straightforward result of what the photographer arranged in his viewfinder.

There are limited opportunities for the photographer to improve or change his result. He has the facility for creating unrealistic images by multiple exposures, by using colour filters, printing only parts of the image, sandwiching together two or more negatives. There are methods of turning a normal photograph into a creative abstract work of art that make use of the chemistry which is exclusive to the art of photography: bas relief, solarization, infra-red, posterization, but all these depend upon improving an already good picture.

In recent years the photograph has become established in the world of the visual arts as an acceptable art form in its own right. High prices can be paid for modern photographs and pictures of some antiquity have become collectors' items. Photographs can be found in the place of honour over the mantelpiece and on the boardroom walls where the gilt-framed painting was once invincible. Many of these photographs are the works of amateurs who share the experience, the imagination and the expertise of the finest professionals.

7. Developing a Film

Developing an exposed film, to turn it into a permanent negative is simple and economical. A special darkroom is not essential at this stage. There is no need at all to get involved in the complicated business of chemical formulae. Anyone capable of producing a good cup of tea is more than halfway to producing a reasonable negative. The result may not be professionally perfect but it will certainly be more than adequate for home processing of many successful prints.

The process is simply a matter of following a few easy operations. There are no special tricks of the trade for turning a perfectly exposed film into a perfectly good negative. The complicated techniques that some photographers describe are more often used to make up for the shortcomings of a badly exposed film. With a properly exposed film there are no special tricks at all – no special experience is required. Just follow the recipe and a good result must follow.

The developing tank

It is usual these days to do all the developing in a tank. Once the exposed film is safely inside the tank the process is carried out in daylight or normal room light.

The tank is a small round, lightproof box with a special light-proof hole in the lid through which the developing chemicals can be poured. There is a spiral inside on which the film is wound in such a way that each turn of the film is kept apart. There are developing tanks of different sizes for different sizes of film. Some tanks are made with adjustable spirals for different sizes of film.

Loading the tank

Before using a developing tank it is essential to practise feeding the film on to the spiral. Do this in daylight, using a length of old exposed negative film.

Most important, before attempting to load, ensure that the spiral is bone dry. If there are any wet spots in the grooves the

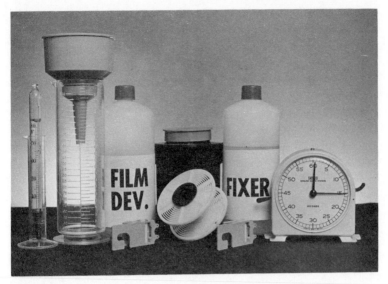

Basic equipment needed to develop a film: developing tank and spiral – 2 measuring flasks – thermometer – seconds timer – film clips – developer – fixer – funnel. *(Ivor Hibberd)*

film will stick for certain. Cut off the tongue of the film squarely with scissors and then nick off the sharp corners of the new leading edge of the film. This leading edge is fed into the start of the spiral.

The two round faces of the spiral are made to turn slightly and by seesawing them backwards and forwards the film is automatically moved along the grooves until the whole film is fed into the spiral.

Another type of spiral is made in such a way that the leading end of the film is first clipped firmly into the central hub of the spiral and the rest of the film is slowly wound round and round following metal guide rails from the inside to the outside of the spiral.

Whichever form of spiral is used, patience will be rewarded. Apart from getting exasperated, one common danger is forcing the film to the point where it will buckle. If this happens it may well cause a slight crease mark that will appear on the picture like a crescent shaped moon – which may require some explanation if it is a daytime picture.

Avoid the temptation to grab the film and force it into place on the spiral. Don't! Film should always be handled by the edges and never touched by fingers and thumb.

After some success with daylight practice on an old film length, further practice in the total darkness or in a changing bag is highly

recommended. When it comes to an undeveloped film, it is essential to place everything you need in the changing bag first. If you are using a darkroom lay everything out systematically so that it is easy to find in the dark: the film in its cassette, the developing tank, separated, with its base, lid and spiral, and a pair of scissors.

Start with the film. Do not yank it out of the cassette by its tongue. There may just be a piece of grit on the light-tight opening of the cassette which will scratch the film. Instead, pull off one of the round sides of the cassette by getting your thumb under it and squeezing the body of the cassette slightly. It will come off easily.

Slide the whole roll of film, still on its spool, out of the cassette and keep it rolled up. The outer turns of the film are the leader with no pictures to spoil, so this may be handled freely.

Films that have paper backing should be separated from the paper slowly and methodically, particularly in a hot dry atmosphere. A static electrical charge can sometimes build up between the paper and the film and this can cause sparks that will appear as tree-like images on the negative, ruining the final pictures.

With scissors, cut off the leading tongue on the film and nick off the sharp corners. Load the film on the spiral in the well-rehearsed manner, keeping the bulk of the film on the spool until you reach the end of the film. At the end, detach the sticky tape that holds the film on the spool and remember to leave it on the spool, not the film.

With the film now loaded on the spool, put it into the tank and replace the light-tight lid – check that it is on properly. The film is now ready to be developed in daylight and can be taken out of the changing bag (or the light in the darkroom may be switched on). With the film safely inside the developing tank it is now ready for processing.

Other equipment

The developing tank will usually have marked on it the liquid capacity in ccs and fluid ounces e.g. 245 cc, $8\frac{1}{2}$ oz. This is the minimum amount of liquid needed to cover the film inside the tank. If less than the stated amount is used, then only part of the film will be processed properly. It is essential to measure the correct amount and it is worth buying one 22 oz. and one 5 oz. inexpensive, *clear plastic measuring jars*; from a photographic dealer.

An old kitchen measuring jug is also handy but it must be reserved for photographic use and not used subsequently for food. *Scissors, clothes pegs* and a *chamois leather* will also be useful.

Another essential piece of equipment is a photographic *thermometer* which clearly marks 20°C – the temperature at which most photographic processes in black and white are performed. 'Clearly marked' means being able to read the scale easily in the poor light of the darkroom. Photographic thermometers are not expensive and are usually made to last a lifetime. They are good value for money.

Not essential, but often very useful is, a *small plastic funnel* for pouring liquids into bottles, and filtering chemicals. *Stoppered brown glass bottles* will also be useful for storing chemicals.

Chemicals needed – developers

Nowadays, it is not necessary to mix up a formula of different chemicals for a developing solution. The photographic manufacturers do this perfectly.

There are two ways of deciding what developer to use. The best and simplest is to buy a developer that has been prepared by a manufacturer specially for his own film material. If the film is Kodak, it is sensible to use a Kodak developer. If the film is made by Ilford, then an Ilford developer is likely to be the best choice and so on. There are several other different developers obtainable made by firms that do not manufacture films themselves but are suitable for all kinds of films.

Whatever developer is chosen it is a good rule to be consistent – at least to start with. Use the same kind of film of the same speed and the same make of developer together – until you gain experience.

Some developers are bought in powder form, complete with instructions on how to mix them into a solution. In spite of the mass of technical information usually contained in these instructions, there are really only two points that need to be understood by the beginner and these are by no means difficult.

1. The packet generally contains two packets of powder. The smaller packet has to be mixed with warm tap water (not hot). Always start with the water first. Get it to the right temperature and the right quantity – usually about two-thirds of the total that will be required – and then add the powder gradually, stirring slightly at the same time. *Never pour water on to the powder. Water first, then the powder is a golden rule.*

When all the powder of the smaller packet is dissolved, the larger packet is then poured in and stirred in the same way. After the powder has been dissolved, more water is added to make up the total volume. This is almost as easy as adding sugar to a cup of tea.

2. It is also necessary to know how long the various types of film (slow, medium and fast films) have to remain in the developing solution. For instance an Ilford HP3 film needs seven minutes and an Ilford Pan F would require four minutes in the same developing solution at 20°C. The table of figures on the instructions will give the correct time.

Fixing solution

The fixing solution can also be bought in bottles of various sizes from the dealer at very little cost especially as the solution can be used several times. There are instructions with every bottle and these, too, are simple. Most fixing solutions need to be diluted according to the maker's recommendation.

The instructions indicate how long the film must remain in the fixing solution when diluted to different strengths but again standardization makes this simple. If the solution is diluted one part fix, to three parts water every time, then the fixing of the film will take, say, seven minutes every time. Do the same thing with the same chemicals with the same film and practically all the doubts and difficulties – if there are any – will vanish.

1. Developing

The film is in the developing tank and the developer has been mixed in the large measuring flask into a solution. First, pour developer into the measuring flask and measure sufficient for the developing tank. If the tank requires eight and a half ounces measure eight and a half ounces in the flask. Check the temperature of the developer. It should be 20°C. If it is too high or too low, cool or warm it by placing the measuring flask containing the developer in a bowl of hot or cold water. When it is 20°C pour the developer into the developing tank. Do not trickle it in slowly, dribble by drip, but pour with speed and determination without spilling any and start to time on a watch or clock.

Once the whole quantity of developer is in the tank give it a couple of fairly hard taps on the work-top to shift any air bubbles that might be clinging to the surface of the film.

The amount of liquid developer in the tank will appear scanty. The tank will seem half-empty. This is as it should be. The tank will have a special cap to fit over the pouring spout in the lid. This should be fitted on and when the tank is turned completely upside down, the amount of solution inside the tank will now be held in

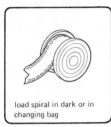

load spiral in dark or in
changing bag

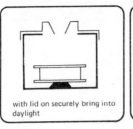

with lid on securely bring into
daylight

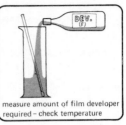

measure amount of film developer
required – check temperature

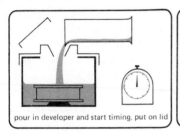

pour in developer and start timing, put on lid

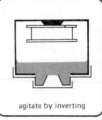

agitate by inverting

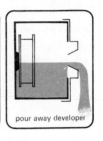

pour away developer

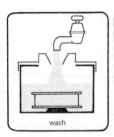

wash

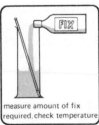

measure amount of fix
required, check temperature

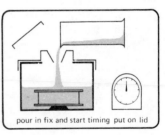

pour in fix and start timing put on lid

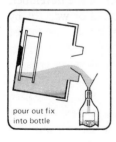

pour out fix
into bottle

wash

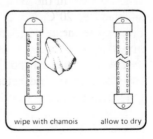

wipe with chamois allow to dry

Developing a black and white film

the lid cavity and the film completely drained. Reverse the tank again
and the film will be completely submerged in the solution. This
agitation by reversing the tank is usually recommended when using
most developing solutions and is generally done every minute during
the developing time.

When the developing time is up, take off the pouring cover – not
the tank lid – and pour the developer away down the sink or into
an empty bucket. The developer has done its work and should not
be used more than once.

2. Rinsing

Next, the film has to be washed to get rid of all traces of developer
and this may easily be done by pouring in tap water, giving the
tank a gentle shake and pouring it out again three or four times.
The tap water should not be more than about 5°C warmer or cooler
than the temperature of the film (which is about 20°C after the
developer has been working on it). A rapid change of temperature
such as pouring ice-cold tap water or using the hot-water tap can
spoil the emulsion of the film irreparably.

A special stop solution is available that can be used instead of
water to ensure the film is cleaned of all traces of developer. It is
quicker to use, but water is effective if it is done thoroughly.

3. Fixing

After the rinse comes the fix. If the concentrated fixing solution
in the bottle needs to be diluted with water start with the water
first. Measure the right amount of water into the measuring flask
and get it to the right temperature or fractionally above the 20°C.
From the small measure, add the quantity of fix needed. For example:
to make twenty ounces of fix diluted one to three, measure fifteen
ounces of water into a large flask to 21°C, then add five ounces of
concentrated fix from the small measuring flask.

This amount can be easily stored in an ordinary, clean glass bottle
with stone screw stopper. Measure off the volume required for the
developing tank (say eight and a half ounces) and pour it into the
tank with the same speed and determination as before, and start
timing. This timing is not so critical. The development time has to
be as near 'spot on' as possible, but the fix timing may be longer –
but not shorter – than the time stated in the instructions.

After the time is up, pour the fixing solution back into the bottle
of diluted fix, using the funnel. It can be used several times. It is

best to do this with the bottle actually in the sink in case the solution overflows and runs down the side of the bottle on to the work-top. Fix solutions contain acid and can stain some surfaces permanently. Wipe the bottle, and its bottom carefully before putting it away in a cupboard.

At this stage the moment comes when, if curiosity conquers patience, the lid of the tank may be removed for a quick peep at the film. Be careful of eagerness and excitement at this moment. The film is wet with acid fixer. Do not hold it up to the light to drip on clothes or possibly into eyes. Just a quick, encouraging peep must do for now.

4. Rinsing

Use clean water and lots of it: running water from the tap into the tank for at least fifteen minutes. The emulsion is still soft and spongey so take great care not to touch it with fingers or allow anything to drop into the tank and on to the film. Keep emptying the tank as the water pours in; give it a shake now and again. When it has had every trace of fixing solution washed and rinsed out it is ready for drying.

5. Drying

Take the film off the spool very carefully indeed. Do not allow it to bend and buckle. Do not touch it with fingers. The emulsion is soft until the film is dry and it is at this wet stage that it can attract every particle of dust there is. It is asking for dust and fluff trouble to be wearing a fluffy woollen jumper.

After unloading the film from the spiral hang it up in a dust-free room; the bathroom is often a good place. One way to hang it is to have a clothes peg of the spring type clipped over a line of string first. The peg is then clipped to the end of the film. Clip another spring clothes peg to the free end to prevent it curling up on itself as it dries.

With a chamois leather which is clean, damp, and well wrung out, wipe the film lightly and smoothly from top to bottom on both sides to remove excess water. Do not try to dry the film out altogether when doing this. Too much handling will scratch the emulsion. A light, smooth wipe to get rid of the globules of water and to 'spread the wetness' should be quite enough.

When the film is completely dry – after about eight hours – it should be very carefully handled still, taken down and cut into sections (six pictures for a 35 mm film).

Special transparent envelopes can be bought for storing film negatives but at first it may be worth using a sheet of smooth clean writing paper, folded to take the film comfortably, with details of the pictures written clearly on the outside for reference.

6. Cleaning up afterwards

Running water is invaluable for the washing stages in developing the negative and it is also a boon in clearing up after each stage. It is essential to wash the measuring flasks after each and every use if chemicals are to remain uncontaminated. If you get chemicals on your hands, it may not be harmful to any but the most sensitive skins but it is always good practice to wash under running water at once. Of course it is just when you have chemicals on both hands that you have an irresistible urge to scratch an itching eye: beware – this can be an unpleasant experience.

The developing tank, its lid and spiral plus the measuring flasks and funnel should be thoroughly washed and dried after every session. It is a good plan to keep a special drying cloth for the purpose or to use disposable kitchen tissues.

Developing and fixing solutions can be stored for several months in a cool temperature, in airtight, stoppered, brown glass bottles. Always soak off the original label of beer or orange squash bottles and put on a new one with details written in very large writing, of concentration, date made and put them way out of reach, not only of children but somewhere even an adult would have to get out a chair to reach them. Then there can be no mistake.

8. In the Dark

The Darkroom

The three most important requirements for any darkroom, temporary or permanent, are *running water* (preferably both hot and cold), *electricity* and *ventilation*. These suggest either the bathroom or the kitchen: either can be turned into very satisfactory temporary darkrooms provided the rest of the household can be persuaded not to come blustering in.

Of course, a darkroom should be dark. It is not difficult to black out the window with light-proof material and drawing pins. Check the light-proofing by sitting in the dark for a few minutes until your eyes have become adjusted and block out all the bad light leaks that will undoubtedly be there. Extra drawing pins may be required at the window frame and you may need a rolled up rug at the bottom of the door.

The danger in making a room totally light-proof is that it can also become air-proof and some form of ventilation must be allowed. A fanlight at the window might be left open. A sash window opened even a fraction at top or bottom will help. If there is an electric ventilator extractor fan in the room then this would be ideal. Working in a darkroom is an absorbing occupation; time flies by and after two or three hours it can become very stuffy. The chemicals give off smelly fumes which, added to the stuffy atmosphere, can turn a fascinating hobby into a headache.

If you are using the kitchen, see that there is no food likely to be contaminated, especially foodstuffs like milk and butter that tend to absorb smells. Clear the sink and draining board and put dish-cloths and tea towels out of the way lest they become splashed accidentally during the process. In the bathroom put towels, face flannels and toothbrushes well out of reach too.

Don't forget the floor. Put away loose rugs that might be tripped over in the dark. Put down some newspaper especially where chemicals are likely to be splashed or spilled.

In arranging the temporary darkroom it is a good idea to think of it as two separate working areas; a dry area for film, papers, and

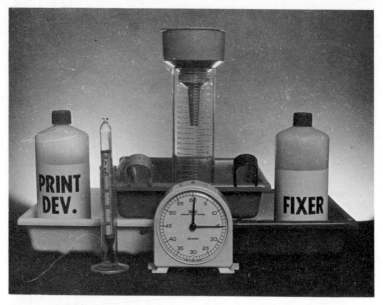

Basic equipment needed for developing a print: 3 dishes – 2 measuring flasks – thermometer – seconds timer – print tongs – developer – fixer – funnel. *(Ivor Hibberd)*

electrical supply and a wet area for developing, fixing and washing. In a kitchen this might suggest a table or a working surface near a power point for the dry area and the sink and draining board for the wet area. In the bathroom, a board (an old flush door perhaps) placed over the bath might serve as a dry working surface and a small table next to the handbasin as the wet area. Whichever room is used, give a cautionary thought to the problem that electricity and water are bad companions – particularly in the bathroom – and like all bad companions must be kept apart.

Equipment needed

The first, essential, piece of equipment needed is a 'safelight'. If you intend to do a fair amount of darkroom work it is wiser to invest in a proper safelight than to make do with a red bulb in the normal overhead light.

The safelight is basically a box with a special coloured glass screen, illuminated by a fifteen or twenty-five-watt bulb and is cheap to buy. The coloured glass screen which filters the light is specially designed to give a fair amount of light in the darkroom, enough to see where you are and what you are doing but the colour

of the light has no effect upon the light sensitive film or printing papers.

There are different coloured glass screens for different kinds of film and paper and the instruction leaflet supplied with each packet of printing paper will show which kind of safelight screen should be used.

The next essential is three fair size developing dishes. These are, again, inexpensive but any plastic, china, glass or enamelled dish large enough to hold a sheet of printing paper will do. But not metal. The processing chemicals do not like aluminium or tin.

You will also need your photographic thermomenter, two measuring flasks, plastic funnel and a measuring jug.

Some accurate method of timing in seconds is also needed, for instance, a stopwatch or a photographic interval timer, but there are many photographers who have the knack of counting off the seconds

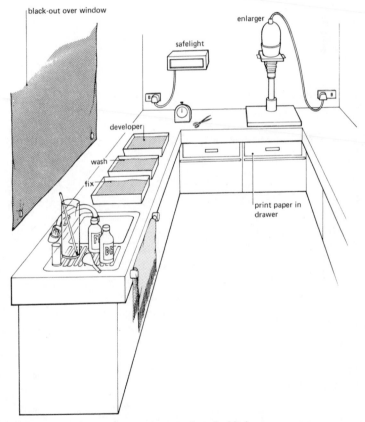

Basic layout for temporary darkroom, using the kitchen

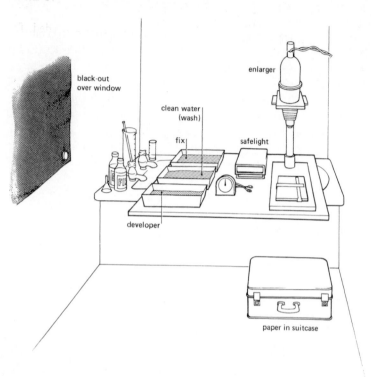

Basic layout for temporary darkroom, using the bathroom

quite accurately without a clock by muttering aloud 'One hippopo-
tamus, two hippopotamus, three . . .'. Perhaps, for a beginner, it is
better to have a more accurate system of measuring time.

Finally, some system of keeping the darkroom warm is often
desirable, such as an electric fan heater or central heating radiators.
Developing chemicals must be kept, ideally, at a constant and reason-
ably high temperature for consistently good results. In heating the
darkroom do remember that a radiant fire, especially a paraffin
heater will burn up oxygen, so ventilation becomes even more
important. The red glow from an open electric fire will ruin some
types of film and printing paper.

Printing papers

The photographic printing paper on which the final picture will
be made is not unlike the film in its basic construction. It has a

paper base with a light-sensitive, silver bromide emulsion layer on one surface. The negative film is placed on the printing paper, emulsion to emulsion and light is shone through the film on to the emulsion of the paper. The negative picture allows light to pass through to the paper in the light areas and prevents light passing through to the paper in the black areas.

In exactly the same manner as when the film was exposed, the emulsion of the paper is affected by the amount of light it receives. It turns black at the places where it receives the light and remains white where no light has reached. The various grades of grey in between the black and white extremes, allow more or less light through to the paper resulting in lighter or darker grey tones on the paper.

After the paper has been exposed through the negative film, it has to be developed and fixed. The developing chemical acts on the silver bromide crystals contained in the emulsion of the paper, turning those that receive a lot of light, black; those that had less light, grey and those that had no light are washed away at the fixing stage later leaving the area white.

After fixing, the emulsion remains unaffected by further light and the picture is now a positive with the whites and blacks and all the grey tones in between as they appeared in the original scene.

Just as there are many different types of film with different film speeds, so there are several kinds of paper produced in many sizes with about six different grades. These grades are generally known as very soft, soft, normal, hard, extra hard and ultra hard. These variations are useful since, by selecting the right grade of paper, a normal picture can be produced from negatives that may be slightly over-exposed (very thin or soft negatives) or under-exposed (very dense or hard negatives). The texture of the surface varies too: glossy, semi-matt and matt. Glossy paper tends to produce very crisp and well defined detail in the picture. The glossy surface may be glazed on glass or by special glazing equipment resulting in a hard shiny finish. The matt paper has a softer effect on the picture detail and is very suitable for portraits. Semi-matt is a good, all-purpose paper with good detail and a wide range of grey tones between pure white and dense black. Some printing papers have a resin coating that prevents the chemicals and water-rinsing processes from saturating the paper base. Using these papers can speed up washing and drying times considerably.

The choice of papers is wide and the recommended way of starting is to choose a semi-matt paper of normal grade. Master the basic operation of printing with this then it is easier to understand the results that can be achieved with harder or softer paper.

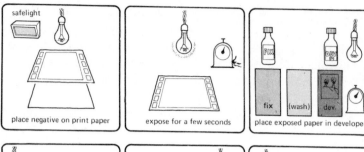

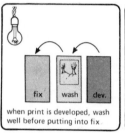

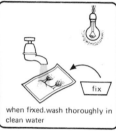

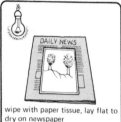

Contact printing

Contact printing – the process step by step

Switch the room light off and the safelight on, then wait a few moments for your eyes to become adjusted to the low light level. Take one piece of printing paper from the packet – cut it with scissors to about the size of the negative and put the rest of the paper back into the packet at once. Ensure that the packet of papers is wrapped up and light-proof every time a piece has been removed. Never take out more than one paper at a time and if possible keep the packet in a drawer.

Lay the paper down on a clean surface, emulsion side upwards. Place the negative on the top, emulsion side down. If there is any doubt about this, the emulsion side of the paper usually looks slightly shiny. The right way up for the negative can be determined if there is any doubt by looking at the picture in the safelight and placing it on the paper in the way the picture is to be printed. If the trees were on the left and the buildings on the right of the original scene when the photograph was taken then that is the way it goes down on the paper.

Over the top, place a clean piece of clear glass to prevent the negative moving and to ensure that it lies flat on the paper. Check once again that all paper has been put away safely. Turn on the room light and start timing in seconds. The actual exposure time will depend upon the amount of light there is and the grade of

paper so this first exposure must be a test. Give the exposure between five and fifteen seconds depending upon the amount of light in the room and how close the light is from the paper and negative. Then switch off the light. After development and fixing, judge if more or less exposure was needed and if necessary do another test. Once the correct exposure has been found, make a note of it, and its position on the working surface, for future occasions. If the position is moved further away or nearer to the light source at any time the exposure will have to be altered.

The chemicals

The printing paper is processed using a very similar method to that of the negative. It is developed, washed, fixed and washed again – and this process is perhaps one of the most fascinating in all the various stages from taking the picture with the camera to the finished print.

The developing solution for print paper can be bought from the dealer either in powder form or ready made up into a concentrated solution. If you use powder, the mixing instructions are the same as used for the negative developer – remembering always to start with the water first, adding the powder to it. The instructions leaflets with every packet and bottle of developer are very detailed but, at this stage, it is enough to follow the mixing instructions carefully.

When the solution has been made up and put into a clean glass bottle with a screw stopper, make out a label which states clearly that it is for prints and not films, the date it was made up, and, if it is a concentrated solution, how it has to be diluted. Developing solutions for films and papers should be kept for their own exclusive use.

The fixing solution that was used for processing the film, however, is perfectly suitable for papers and can be used several times over in both processes. There is a limit to how often the fixer can be used. It will do for many rolls of film and a large number of papers before it becomes exhausted.

If the developer and the fixer are concentrated solutions, dilute according to instructions and check the temperature. They should both be 20°C. Pour into separate developing dishes enough to cover the prints when they are being processed – a depth of about one centimetre should be adequate. Pour fresh water, also at 20°C, into the third dish. The three dishes should ideally be lined up side by side; the developer first, then the water, then the fixer.

After the print has been exposed, the room light switched off and the safelight switched on, the paper should be put first into the developer, picture side up, sliding it under the surface of the solution so that it is all covered evenly and quickly. After about thirty seconds, you will see parts of the picture 'coming through'. Gradually the whole picture continues to emerge during the next two and a half minutes until all the details are clear and well defined. At this point, it stops developing and is the perfect picture. At least, that is what is supposed to happen. This is one of the most exciting parts of photography for any photographer.

But there can be disappointments. At one extreme, the paper in the developer will start developing nicely and then go blacker and blacker, finishing up as a perfect picture of nothing. This means the exposure was far too long. At the other extreme, the detail of the picture does not appear after twenty or thirty seconds in the developer, but by waiting and agitating the paper, for about another two minutes, wishy washy parts of the picture begin to show up grey and wraith-like. This means the exposure was far too brief. Between these two extremes lies the perfect exposure.

When the picture in the developer seems to have had enough development with clearly defined detail, good black areas, clean white highlights and evenly graded in the greys, it should be lifted out of the dish by one corner and the surplus solution allowed to drain off into the dish. It is then put into the dish of clean water and washed for a few moments to prevent any developer contaminating the fixer.

After washing, again allow it to drain by holding it up by one corner over the dish and when it has stopped dripping, place it in the fixer, face down, covering it with the solution and leave it for about ten minutes. Make sure it remains under the surface during this time. It may have a tendency to float and parts of the picture surface may not be getting fixed.

After ten minutes in the fix it is a permanent picture, but now every bit of the fixer must be washed out of the print or it will stain badly when it is dry. This washing is best carried out in running water in the sink for at least half an hour, agitating the picture in the water, and if more than one print is being washed, separating the prints from each other to eusure no surface is being missed.

When the print has been washed sufficiently, drain it, lay it out on newspaper and remove as much surplus water as possible by dabbing with a clean fluffless cloth, a chamois leather, or an absorbent paper tissue and leave to dry naturally in a dust-free atmosphere.

9. Enlarging

The Enlarger

Enlargers can be expensive. Like cameras the more complicated and flexible the apparatus the more costly it is but it is always a good plan to buy the most versatile enlarger with a really good lens that you can afford. Not a great deal can go wrong with an enlarger and a well-chosen second-hand one can often be excellent value for money as well as providing years of reliable service.

The degree of enlargement depends upon both the height that the head of the enlarger can travel up the vertical column and the focal length of the enlarging lens. A negative is placed in a container called the 'carrier', between the lamp and the lens and the image is projected downwards on to a baseboard attached to the column. The printing paper is kept flat on the baseboard, either by little weights at all four corners, or double sided sticky tape.

The best method, however, is to invest in a masking frame. These are metal-based, of varying sizes up to 20×16 in. with a hinged metal frame that fits over the paper and holds it down flat. One long side and one short side are adjustable to hold paper of different dimensions.

The other items of equipment needed for enlargement work in addition to the print developing equipment already used in contact-printing are, of course, three developing dishes big enough to accommodate the larger printing papers. To decide what size of dishes will be required is a matter of personal judgement but a rule of thumb guide is the size of printing paper generally available: $3\frac{1}{2} \times 4\frac{1}{2}$ in., $3\frac{1}{2} \times 5\frac{1}{2}$ in., $4\frac{3}{4} \times 6\frac{1}{2}$ in., $6\frac{1}{2} \times 8\frac{1}{2}$ in., 8×10 in., 10×12 in., 12×15 in., 20×16 in. A few disasters with small enlargements may be put down to experience, but a number of mistakes with 20×16 in. paper can seriously dent the budget. Standard sizes of masking frame and dishes for enlagement work are 10×8 in., 10×12 in., 12×15 in., 20×16.

Using the Enlarger

Place the negative in the carrier, emulsion side downwards so that you see the projected image on the baseboard or masking frame as

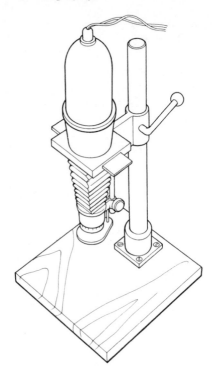

An enlarger

it will appear in the final picture. Such is the optical arrangement of the enlarger lens that the negative has to be placed in the carrier with the bottom of the picture upside down for the picture to appear the right way up on the baseboard.

Switch the enlarger light on and, with the enlarger lens at its maximum aperture, adjust the height of the enlarger head up or down to more or less the right size to cover the area of the paper to be used. The projected image is then focussed carefully until it is pin sharp on the baseboard. The lens aperture is now set to a smaller size – about f/8 and the enlarger is switched off again.

By the light of the darkroom safelight, take one piece of paper from the packet and place it on the baseboard or easel, emulsion side up. Immediately underneath the enlarging lens is a red safety filter that can be swung under the lens. This is used to check that the picture is projected on to the paper properly by switching on the enlarger light with the filter in place. The red image will not affect the paper and all final adjustments may be made safely. The light is switched off again, the red filter swung back out of the way, the enlarger light switched on and the timing of the exposure begins.

The test strip

The price of large paper prevents a series of trials being made with full sheets of paper. Instead, take one sheet from the packet and, from the shorter side, cut off a strip of about one inch. A strip one inch wide and about four inches long will be sufficient for a test. Return the rest of the paper to its packet. Swing the red safety filter over the lens and switch the enlarger on. Decide where, in the picture, the best test of exposure might be made: clearly not on a broad

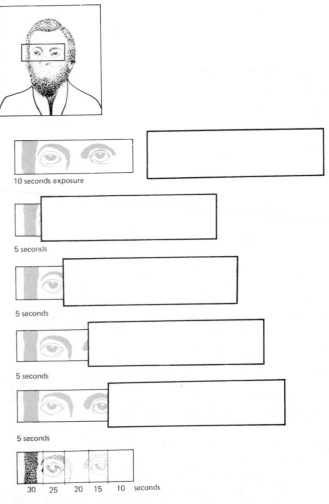

10 seconds exposure

5 seconds

5 seconds

5 seconds

5 seconds

30 25 20 15 10 seconds

Steps in making a test strip

expanse of grey sky but a place where there are variations of tone and detail. Place the strip in that area and switch off. Swing the safety filter out of the way.

Some judgement must be made to decide roughly what the exposure might be at the chosen degree of enlargement at this stage. If the enlarger head is about halfway up the column a rough guess might be say, twenty seconds with the enlarger lens stopped down to f/8. The enlarger light is switched on and ten seconds of exposure to the whole test strip is given, and the light switched off. A piece of card, an old piece of photographic paper perhaps, is placed over most of the test strip without shifting the strip, leaving one end, about one-fifth of the length, open for another exposure – this time for five seconds. The card is then moved carefully to leave two-fifths open at the end, then three-fifths, then four-fifths, each section being given five seconds of exposure. When this has been done the last section which remained uncovered will have had the first ten seconds, the next fifteen seconds, the next twenty seconds, the next twenty-five seconds and the last section has had all the exposures adding up to thirty seconds.

This strip is now developed, washed and fixed and can be studied in the room light to determine which of the five exposures gave the best result.

Having determined the best exposure time it will probably suit several negatives on the same roll of film providing they are all of the same quality. Remember, however, that this exposure only holds good for enlargements of that particular size with the lens set at f/8. Any variation of the enlarger head up or down the column or a different setting of the lens aperture will require a new test strip.

There are several pieces of measuring equipment on the market specially designed to determine, quite accurately, what exposure may best be given for different kinds of print paper but the test strip system is a simple, cheap and accurate way of getting a first-class result, even if it does take a few extra minutes to do.

Some of the problems

One of the bugbears of enlarging is that every microscopic grain of dust on the negative, every scratch and finger print will be magnified maybe ten or fifteen times and this is one of the main reasons why you should take great care in handling the film at all stages from the time of loading right up to the printing.

The carrier of the enlarger may be constructed with two glass screens in which the negative is sandwiched and these will pick up

dust in all but the most clinically clean atmospheres. Glassless carriers are made to prevent this but the film negative itself will attract dust and in studying the projected image on the baseboard before exposing, look for the dust spots in the picture and remove them with a clean, soft chamois or a slight puff of the camera brush.

When the enlarger head is at the top of the column for big magnifications, it is very vulnerable to vibrations and few enlargers are built like the Forth Bridge. Some people with enlargers permanently set up in darkrooms will fix a stabilizing bracket from the top of the column to a firm solid wall to prevent any column movement and the whole apparatus is sometimes fixed on a solid concrete base. This is not recommended practice for the amateur in the kitchen or bathroom but it does suggest why some pictures may turn out to be less sharp than they should be.

Some negatives may be very difficult to focus on the baseboard or easel; they may be soft-focus pictures, mist and fog scenes for instance. It can be a problem to decide if the enlarger is truly in focus. One way out of the difficulty is to make a scratch with a needle or pin on the edge of the negative, just outside the actual frame of the picture and this can be used as a focusing aid.

An inexpensive gadget called a focus finder may help, too. A focus finder is placed on the baseboard, the photographer looks through the eyepiece and adjusts the focus of the projected image by adjustment to the enlarger. When the image is exactly in focus the individual grains of the emulsion of the negative will be highly magnified and sharply in focus.

Dodging and burning in

It would be unusual for any photographer to produce perfect negatives every time. Some negatives will be worse than others for varying reasons but with the enlarger, a great deal can be done to compensate for slight over or under-exposure or variations of light and shade in a picture. If, for instance, a large white area of a negative (which will come out black on the print) is too dominant compared with the more subtle detail in the rest of the picture, it may be given less exposure than the rest by 'dodging'.

Cut a piece of card of roughly the same outline shape as the area to be dodged and attach it to a piece of thin wire. During exposure hold this cut-out mask between the lens of the enlarger and the baseboard to throw a shadow on to the white area. With practice you can judge how many seconds less exposure the area should be given to finish up with an evenly exposed, acceptable picture.

Enlarging a part of the whole
negative can often produce a much
better picture. *(Ivor Hibberd)*

A selected part of the previous picture
produces an upright format and closer
attention is now given to the subject.
The dominance of the buildings behind
contrasts with the concentration
of the two ladies who appear to be
indifferent to their surroundings.
(Ivor Hibberd)

Conversely, a black area on a negative (which would come out white on the print) can be 'burnt in' by covering the rest of the projected image, leaving only the black area. What little light there is penetrating the negative will reach the paper after a fairly long exposure and again, personal judgement will decide how much should be given for the desired result.

Selection

The whole picture area of the negative is projected by the enlarger on to the baseboard but not all of it needs, necessarily, to be printed. If the enlarger head is run to the top of the column, large

magnifications of only a small part of the whole picture can be printed. This is where the masking frame is useful in framing up just that part of the picture that is needed, cropping off the rest. Selecting a small part of the picture is where a degree of creative work is involved. A picture with poor composition may be reorganized by eliminating an indifferent background. It is also possible to find, within a single picture, several individual parts that, in themselves, are probably better than the whole scene.

Multiple images

By exposing part of a negative on to part of a print paper and, afterwards exposing another part of a different negative on to the same paper, an entirely new picture can be created. The technique can be used in landscapes where the sky is, unfortunately, a plain light grey mass, devoid of clouds. Using another negative of suitable clouds, these can be printed in separately. The cloudless negative is printed in the normal way but the sky area is masked by dodging and holding back the exposure. The negative is changed in the carrier for the negative of clouds and tried out on the easel for exact position through the red safety filter over the lens. When exposing the clouds, the landscape area, already exposed on the print, must be masked off to prevent any overlapping. Take care to get the right exposure so that both landscape and clouds appear to be natural.

Two indifferent negatives when sandwiched together in the carrier can sometimes produce quite startling results providing the negatives are not too dense and sufficient light can penetrate the two to give a satisfactory result.

Photograms

A negative is not necessary to produce a picture at all. Leave the carrier empty with the enlarger head raised well up the column so that its light will cover the area of printing paper on the baseboard. Switch the light off, and place a piece of printing paper on the baseboard. Select a decorative object, preferably flat, such as a lace handkerchief or doyley or an intricate patterned leaf and arrange it in a pattern on the paper. Expose the paper by the light of the enlarger and the result will be a clear white image on a black background. By arranging different shaped objects in various patterns over the paper many ingenious and appealing photograms can be made.

10. General Advice

A camera bought new or second-hand will rarely be in unworkable condition but each and every one has its own little idiosyncrasies, particularly with exposure. Although shutter speeds are marked clearly enough, it is seldom that they are really what they say they are and no two cameras will be alike. The speed of 1/125th of a second, for instance, when accurately measured, will be found to be anything but 1/125th of a second. It could be 1/120th or 1/136th or any number at roughly that speed. The more expensive the camera the smaller the error, generally speaking, but this error is of no great concern since it remains constant.

With any camera it is essential to get to know how it performs under different lighting conditions and this requires the new owner to make a note of the conditions, the shutter and aperture settings, the speed of the film used and a brief identification of the picture content. After two or three rolls of film used in different lighting, the message will begin to be clear: that, say, 1/15th of a second is rather slow and tends to over-expose slightly; that 1/200th is rather faster and tends to under-expose; that all the shutter speeds are consistently slower or faster than stated and to compensate, the exposure must be increased or decreased by half a stop or the film speed rated at a higher or lower figure.

Learning how a camera behaves with two or even three rolls of test film will save money and disappointment later. This is true, too, of accessories like the electronic flash gun whose guide number may not be quite correct for a correct exposure. After trials, a more accurate guide number can be calculated which will then produce consistently accurate exposures.

Photographic equipment is generally beautifully constructed with great care and precision. Every part has been designed to give a long period of smooth efficient service but it still needs careful treatment. Apart from routine cleaning and blowing it should be stored, when not in use, in the cases provided or a camera bag. These must be cleaned out and defluffed from time to time. A little sachet of silicone crystals will absorb moisture in the atmosphere in the bag and will prevent metal parts from corrosion.

It is not wise to keep a half-exposed film in the camera for any great length of time say, from the summer holidays' until Christmas. Neither the exposed pictures already on the film nor the unexposed part of the film will benefit.

If the camera is to be laid up for a few months, remember to release the shutter. Keeping it for some time with the shutter 'wound up' may affect the shutter speeds. After loading a 35 mm camera with a cassette, the two wind-on-past-the-leader-operations should be done using a shutter speed that is not often used, say $\frac{1}{2}$ second or 1/1000th second to keep the mechanism in trim.

Never use lubricating oil, even machine oil, on a camera or the lenses. They do not need it. A camera is one of the few machines with moving parts requiring no lubrication. If the works jam, it is probably for some other reason than friction and the photographer's shop is the place to turn to, never the oil can. Only one thing is worse than oil – a screw driver!

The changing bag

If only half a roll of 35 mm film has jammed, first note the number of exposures already taken. Clearly, the camera will have to be opened but this need not mean a wasted film. The simplest solution may be to rush to the photographic dealer or the friendly neighbour with a darkroom for the film to be taken out in the dark. Failing that, a changing bag will be invaluable – and these are good value for the little money they cost.

It is simply a bag about two feet square made of black lightproof material with one open side that can be zipped open and closed. At two corners are sleeves, with elasticated cuffs. The bag is zipped open; in goes the faulty camera and the bag is zipped closed again. Arms go into the sleeves which turn inside out as the hands go into the bag with the elasticated cuffs holding firmly around the wrists. Inside, it is completely black and light-proof and the camera can be opened fairly easily by feel and imagination.

Quite often the sprocket holes on the one or both edges of the film will have torn and these jagged edges on the film can usually be felt with the fingers. If this is the case, close the camera again with the film still inside, open the bag, pop in the cassette tin and maybe a pair of scissors and zip the bag up again.

Once inside safely, open the camera and cut the film, on the un-exposed side of the damaged film; the side towards the cassette. Pull the already exposed part of the film from the take-up spool, put it into the cassette tin and secure the lid. That will serve in an emergency

and be lightproof enough for the time being. Now check that the shutter and winding mechanism are working properly and, if so, trim the leading end of the unexposed film remaining in the cassette into a new tongue with the scissors and feed it into the slot of the take-up spool in the normal way. Close the camera and the camera is ready for action again for the remaining number of exposures left in the cassette – less two or possibly three exposures that have been used as the new leader.

The exposed part of film in the tin should be kept in the changing bag and out of the sunshine until it can be wrapped in silver paper or something really light-proof before getting it to the photographic dealer or the darkroom for processing. It is best to have both parts of the film processed at the same time.

A changing bag is invaluable as a portable darkroom when it comes to taking film out of the camera and loading it into a developing tank for home processing.

Presentation

Slides that are likely to be handled, shown and perhaps submitted to competitions should be put into special mounts between glass. These mounts are not expensive and can be bought in boxes of about twenty-five. The glass covers sometimes tend to squeeze the slide and, when projected, a series of rings appear in the picture, called Newton Rings. There is not much that can be done about this except to change the glass to a slightly more expensive glass that is described as anti-Newton Ring glass. These glass covers have a smooth and a rough surface which is hard to detect by just looking at them. The prescribed manner of finding out is to run the point of a pair of scissors across each surface. The smooth side will produce very little noise. The rough surface will be distinctly heard. The rough surface of each glass is placed on the inside on either side of the slide and the plastic or metal frame is then secured.

A standard, international method of deciding which way round a slide is to be viewed, is to attach a self-sticking, coloured paper spot at the left-hand bottom corner of the slide mount when the slide is viewed correctly.

Prints can also be protected from bending or creasing by being mounted on thick card or hardboard. It is customary to fix a print on a mount with an equal margin at the top and sides and a slightly larger margin at the bottom. There is no strict rule about this and many photographers prefer to 'flushmount' their pictures – some on thick wooden chipboard – with no margin at all.

a slide mounted between glass in a plastic or metal mount should have a self adhesive spot fixed to the bottom left-hand corner

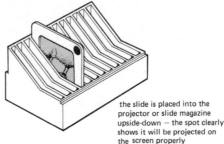

the slide is placed into the projector or slide magazine upside-down — the spot clearly shows it will be projected on the screen properly

Spotting a slide correctly

Coloured card mounts are often used for colour prints where the colour of the mount is compatible with the colour tone of the picture. Black-and-white prints tend to look their best on white or black mounts but, again, this is a matter of personal judgement.

Fixing the print to the mount can be a difficult business to do properly without air bubbles bulging up under the surface of the picture.

One method that many amateurs manage well, after a few initial trials and disasters, is to use a special print mount fixative which can be bought very cheaply in packets. This fixative looks just like sheets of thick tissue paper. The material is cut with scissors to match the photograph to be mounted. If it is a large print, separate pieces are 'tacked' to the back of the print by touching them lightly with a hot – but not very hot – household iron. When the adhesive material is all in place and the whole area has been covered, the photograph is placed upon the mount in the right position. A piece of clean paper is placed over the picture itself and the hot iron is used and worked, from the centre outward, over the whole surface. The iron should not be so hot that it scorches the covering paper but hot enough to melt the adhesive tissue between the picture and mount.

A clean dry cloth screwed up into a ball, pressed on the picture immediately after the hot iron will help to hold the picture firmly in place until the melted glue of the tissue has cooled and reset.

A quick, simple way of marking up a mount is to place the picture on the mount and slip it to the top left corner so that the top and side edges of the picture are flush and square to the top and side edge of the mount. Take a strip of paper and place this with one end touching the right-hand edge of the picture and mark on the strip, the point where the right hand edge of the mount lies. Cut

slide print to top left hand corner
of mount

cut strip of card the exact width of
right hand border

fold strip exactly in
half (crease well)

The folded strip will give an equal margin
on either side of the print – judge top and
bottom margins and lightly mark corners
with a soft pencil

Mounting a print with borders

the strip off exactly at the mark. Fold the strip in half. The length
of the folded strip is now the exact width of the margin and will be
equal at the top and both sides. The bottom margin will be found
from personal judgement of what looks right.

When the picture has been positioned correctly on the mount, the
four corners should be marked very lightly indeed in soft pencil.
The pencil marks can be erased after mounting. On the back of the
mount enter all the technical details of the picture, title, name and
date.

Never write on the back of an unmounted print. Always write
the details on paper and then stick this to the back of the picture.
Writing will inevitably show through on the surface of the picture.

Anyone wanting to improve their standard of photography would
do well to join a photographic club. Most public libraries keep
a record of names and addresses of secretaries of clubs in their
area. Most club members are genial, friendly people and very few
clubs have more than half a dozen real experts who know it all.
The vast majority just enjoy taking pictures, showing them and
seeing other peoples' pictures. Progress comes from seeing other
people's efforts and hearing the comments of experienced judges in
competitions. Another route to improvement is the local authority
adult education centre. Most of these offer classes in photography

which are for beginners or advanced students. Enquire again at your library for details. There are several magazines published weekly and monthly, like *Amateur Photographer, Photography, Practical Photography, Camera User, Photo Technique, S.L.R. Camera,* all of which have articles aimed particularly at the amateur to encourage him to improve the quality of his pictures and his enjoyment of the hobby. They all have a readers' service that can provide practical answers to problems a beginner may find difficulty in solving for himself.

Pictures in books, newspapers, on television, on the hoardings have never been so prolific. We live in an age of visual impact and there are examples everywhere of highly competent picture making. A great deal can be gained from looking to see how a certain effect was achieved in these pictures; what lighting was used; what photographic trick of printing was employed; what information can be read in the content of the picture.

The style of some professional photographers may strike a chord of sympathy: a style that might be followed, even copied. It is often helpful to make a file of photographs from journals or magazines where the technique, the content or the poses have a strong personal appeal. Later, browsing through it, many new ideas for photographs will spring to mind.

There will be fewer of those moments when the sun shines and you cannot find a picture to photograph. Pictures are everywhere and every individual photograph is the personal, creative act of the photographer, whether it be a highly technical and complicated studio shot or the simple, natural emotion that prompted a memorable snapshot.

The instructions in this book have been carefully devised to eliminate the likelihood of failure. However, even the best photographers can occasionally produce dud pictures. The following trouble-shooting guide should help you diagnose the cause of the most common difficulties.

Table I FAULTS

EFFECT	REASON	REMEDY
Film is totally black after processing.	(a) Film has not been exposed. Tongue of film not attached to take-up spool properly. (b) Lens cap left on lens.	(a) Watch rewind handle unwind as each frame is wound on. (b) Check lens cap is in the hand not on the lens.
Film is very black but traces of pictures can be seen.	(a) Film has been badly under-exposed. (b) Exposure meter at fault. (c) Wrong film speed used. (d) Faulty shutter speed. (e) Wrong aperture selected.	If automatic exposure on camera, suspect rundown meter battery. Check film speed setting on automatic exposure cameras. Suspect faulty shutter operating at too fast a speed. Check by comparing a fast speed with a slow speed: the sound should be different.
Whole film is darker than it should be or lighter than it should be.	Under-exposed or over-exposed.	(a) Suspect exposure meter reading, shutter and film speed as above. (b) Suspect processing fault, particularly black and white films.
Streaks of light running into pictures from the edges.	Light has penetrated the film cassette or roll when loading or unloading.	Always keep film in the shade when loading and unloading. If more than one film spoilt, check camera for lightproofing (very rare).
Heads or feet always seem to be cut off by the frame.	(a) Faulty alignment of viewfinder. (b) Not looking squarely through viewfinder.	Photograph a test card and check exactly what will be recorded on the film. To make a test card, draw an oblong about 12×9 in. (if 35 mm camera), 12×12 in. (if $2\frac{1}{4} \times 2\frac{1}{4}$ in. camera) and line up the oblong in the viewfinder with an equal margin all round. Most cameras photograph a little more than the viewfinder shows.
A line or lines across every picture on the roll.	Scratches on film.	Tiny grain of grit or dirt in the mouth of the cassette. Skag on pressure plate inside camera. Use blower brush when loading and unloading.
Half the picture is OK but half is very dark.	Focal plane shutter not operating properly.	Do not try to oil or investigate. See the dealer or reputable repair firm.

EFFECT	REASON	REMEDY
Using flash bulbs or electronic flash all pictures are very dark.	Bulbs (or unit) do not fire. Shutter speed too fast.	Suspect connecting cord. Detach from camera and short circuit the plug with a pin to fire bulb. If OK, check camera setting for X or M. If OK, suspect camera mechanism (very rare) and take to dealer.
Flash pictures on colour film all have orange tint.	Wrong flash bulbs used.	With 'daylight' film, use blue tinted flash bulbs. If using clear bulbs, a blue conversion filter is needed over the lens. Use 'artificial light' film.
Pictures are not clear.	(a) Camera shake. (b) Wrongly focused. (c) Lens misted over by condensation when taking camera from cold to warm warm atmosphere.	(a) If a portrait, look for 'catch light' in the eyes. They should be clear round dots. If like a bar, then camera shake is the fault. Check stability of tripod: use cable release. Look for signs of the picture being 'dragged' for camera shake. (b) Check focusing – some part of the picture should be 'sharp'. Use smaller aperture for greater depth of field. (c) Let lens and camera warm up. Wipe lens gently with lens cloth.
All pictures on the roll have black rounded corners.	'Vignetting' caused by using a lens hood that is too small for the lens.	Get dealer to advise on correct size for lens.
Black, out-of-focus object in picture area.	Something placed in front of the lens; finger? thumb? flap of camera case?	Remember the cost of film and try to handle camera better in future.
With colour film used for interior shots the pictures are greeny-blue.	Fluorescent lighting effect.	Can be improved slightly by using clear flash without blue filter.
One or two black pictures on the roll.	(a) Intermittent non-exposure. (b) Intermittent exposure in total darkness.	(a) Have shutter mechanism checked. (b) Shutter fired with lens cap on lens when putting camera into case.

Index